STAR WARS

RETURN OF THE JEDI

THE ILLUSTRATED

SCREENPLAY

STAR WARS

RETURN OF THE JEDI

THE ILLUSTRATED
SCREENPLAY

LAWRENCE KASDAN

AND

GEORGE LUCAS

THE BALLANTINE PUBLISHING GROUP
NEW YORK

A Del Rey® Book
Published by The Ballantine Publishing Group

http://www.randomhouse.com/delrey/

Library of Congress Catalog Card Number: 97-97056

ISBN: 0-345-42079-9

Manufactured in the United States of America

First Edition: April 1998

10 9 8 7 6 5 4 3 2 1

RETURN OF THE JEDI

Introduction by
Howard Kazanjian

As I am able to write this introduction in 1997, I can look back at how movies were made yesterday, and how they are made today. I can see the large studio effects movies costing $80–200,000,000 each. What the megabudget effects pictures lack, and what the three *Star Wars* films have, is a *story* interwoven with effects. A story with characters you cared about, and a story you could remember years later *along* with the spectacular effects. Many of today's films leave us only remembering the effects and not the story. The *Star Wars* trilogy is a fantasy that has a place in the hearts of two generations of moviegoers. Few films can boast of this.

Star Wars was to redefine film technology and filmmaking as we know it today. It established new highs with its wonderful characters and story, the number of special effects shots, the music, and the editorial pacing. It created a new film genre that has remained popular ever since. With these films George Lucas was to make a turning point in 20th-century cinema.

Return of the Jedi is the third film in the *Star Wars* trilogy. It is the third act of a three-act play. In structure, the third act can be the most difficult to write, as all questions and situations created in the first two acts must be satisfactorily resolved. *Return of the Jedi* would have to answer who the 'other' was, how Han Solo was to be rescued,

and whether Luke would turn to the dark side and join his father Darth Vader. New characters and exciting situations had to be created and interwoven into the story. And there needed to be an exciting conclusion— the wrap-up of all elements and fragments that would bring the characters and story to a triumphant closure.

George asked me to produce *Return of the Jedi* while I was doing preproduction on *The Empire Strikes Back*. At this time in 1981 we were scoring *Raiders of the Lost Ark* in London. While in London, I was to begin meeting with key personnel at EMI Elstree Studios for *Return of the Jedi*.

George came to London in the fall of 1981 to see the sets, props, Ewoks, and, of course, Jabba the Hutt. He would return again with his family a week before shooting and he remained on the set until the last day.

George had daily input in every area of production. He lived every part of the movie with diligent preparation leaving his fingerprints in each department. In the morning he would check with Ralph McQuarrie on his conceptual designs, or with Joe Johnston and other artists on storyboards, props, and sets. In the afternoon there would be a costume design meeting and a visit to the creature shop. Then George would return to his study and continue to enhance the script. This continued for months until the official full-time preproduction began in the United States and London. In late 1981 nine giant soundstages were built in London with sets. Construction in Northern California (Endor) and Southern California (Tatooine) was well under way, and special effects work was moving forward in San Rafael at ILM. Principal photography began in London in November, 1981.

The Sarlacc Pit (Tatooine Dune Sea) with Jabba the Hutt's barge was the largest set ever constructed in California. Construction began eight months prior to shooting with the first shipment of $1\times1\times30$-foot-long beams ar-

riving in Buttercup Valley on the California/Arizona border. Our first shipment of nails alone weighed 11,000 pounds. When we began shooting, each morning 7,000 tons of sand would be needed on the elevated set floor to replace the sand the desert winds would blow away each night. It took a crew of about twenty men each day to maintain our Tatooine Dune Sea.

Another tremendous set was the Endor Forest. A year in advance of shooting we begin preparing the forest in Northern California—the very area where Steven Spielberg would shoot much of ET. Bulldozers would be needed to terrace the land, remove surface roots, and clear paths for the Ewoks to run. Tens of thousands of ferns would be planted and we would wait the winter out so the plants and trees would look natural when we returned the following early summer of 1982.

Many other challenges arose. We had to raise the set of the Ewok village twenty feet off the ground. During construction, illustrations and video were sent to George Lucas from me in London chronicling our progress. An immediate casting call was put out throughout Europe, as well as in the United States. We needed Ewoks on two continents.

Costumes would have to be made from scratch to fit the individual wearing the Ewok costume. Molds of their feet and hands were taken so the fur-lined feet and hands would fit comfortably, and to avoid later spills in the forest. Teaching the Ewoks to walk took weeks of rehearsal, along with exercise to build their endurance. Twenty-four costumers would be needed on the set to help the Ewoks remove their heads between shots. Dozens of portable, battery-operated hair dryers would be used by costumers to force air into the heads of the Ewoks and other creatures between shots.

Jabba the Hutt was designed in the U.S. at the ILM

creature shop by Phil Tippett and his crew, and models were sent to Stuart Freeborn at Elstree where his large crew began the intricate fabrication of Jabba himself.

Yoda would have to be remade, as the head used in *The Empire Strikes Back* was deteriorating. Thousands of human hairs would have to be hand sewn onto Yoda, but tens of thousands would be hand sewn into the new Chewbacca costume. Four new C-3PO costumes, four R2-D2 units, and two new Darth Vaders would be created, as well as fifty new stormtroopers. In the U.S. the Emperor's Royal Guards, speeder bikers, and 400 additional costumes including helmets, shoes and boots, hand weapons and accessories would be manufactured.

Over 100 models of creatures would be approved from hundreds of illustrations, and sixty different creatures would be built, each with props, yet each very different. Some would be men in costumes; some, as the Gammorrean Guards (Pig Guards), were built with extended arms and wire-controlled hands and faces. Sy Snoodles would be created to operate from under the stage floor and from marionette wires from above the set. All these creatures would be rehearsed in the United States, and many of the puppeteers and mimes would come directly from the U.S. to operate them in London.

The amazing speeder bike sequence would be created at ILM; the bikes were built nearby. A new handheld VistaVision camera would be designed and built to shoot the plates in Crescent City, California, the redwood forest.

The Empire Strikes Back contained more effects than any picture in the history of the movies. That number would be dwarfed by *Return of the Jedi*, which reached high in the 900s. The technology and craftsmanship

would be the greatest ever done and would bring an Oscar to ILM/Lucasfilm. The majority of these special effect shots would be orchestrated at ILM. We were the cutting edge of technology. But even then we would have to hand paint 15,000 frames of laser swords. We did not have today's computer graphics to help us out. The only computer-generated material for *Return of the Jedi* was the holographic model of the Death Star that appears in the Headquarters Frigate (the main briefing room scene where Mon Mothma and Admiral Ackbar prepare the Rebel forces for the Death Star attack). Constant communication between the shooting company in London and ILM outside of San Francisco, California, was necessary. Time delays were eight hours and the fax machine did not exist.

All of our preparation in London, Northern California, Southern California/Arizona border, and San Francisco would be made under the strictest secrecy. The Lucasfilm production office in Marin County was under heavy lock and key. Buildings were alarmed as were individual offices such as mine. Millions of fans around the world were curious to find what would be revealed in the third film. Even the title of *Revenge of the Jedi* was changed to *Return of the Jedi* only months before the release. The first one sheets appearing in theaters boldly said *REVENGE OF THE JEDI*.

During the entire production, only three full and complete scripts existed: George Lucas's, Director Richard Marquand's, and mine. Richard continually wrote in his and it got quite beat up. I do not believe it existed much after production. Until years later when scripts were printed for other reasons, George and my scripts were the only full and original copies.

Crew members did rally around and keep any secrets

they did know. We all wanted to surprise the waiting audience. When shooting in the United States we called the film *Blue Harvest*. Camera slates, invoices, hotel reservations, call sheets, production reports, and crew hats and T-shirts all read *Blue Harvest*. So when a visitor would ask what are you shooting and we said "Blue Harvest," they went on their way. Can you imagine what would have happened if we had said, "We're shooting the next film in the *Star Wars* trilogy"?

In postproduction, Ian Bryce, who was then one of my production assistants, sneaked into my office and carefully removed my script from my desk. He substituted another look-alike script. Ian's plan was to have my script nicely leather-bound and embossed and then presented to me on my birthday. He had left a note on the false script in my drawer not to panic, but to see Ian. When I opened the gift, I smiled, and then laughed, because the script I had locked in my desk was a fake script. Ian had bound a fake script!

Even the cast were not told about certain scenes until the day they were to shoot them. And then only the actor reading the line would get that information. Darth Vader (David Prowse) never got *any* information. For delicate information lines he would simply count 1-2-3-4, or read a fictitious line similar in character to the real dialogue. Only at the ADR (dialogue looping) session with James Earl Jones would James then be given the line. When it came time to shoot the removal of Vader's helmet, a very small second unit crew, with George Lucas directing, photographed Sebastian Shaw playing the aged and dying Darth Vader.

The entire *Jedi* project, from conception to U.K. and U.S. shooting to postproduction and worldwide release, took three years. *Return of the Jedi* still holds its own

today. Clearly George Lucas has made his mark and place in cinema history. I'm proud to be the producer and right-hand man for this most exciting cinematic adventure.

—Howard Kazanjian

STAR.WARS.
RETURN OF THE
JEDI

THE ILLUSTRATED

SCREENPLAY

A long time ago in a galaxy far, far away . . .

SPACE

The boundless heavens serve as a backdrop for the MAIN TITLE, *followed by a* ROLL-UP, *which crawls into infinity.*

Luke Skywalker has returned to his home planet of Tatooine in an attempt to rescue his friend Han Solo from the clutches of the vile gangster Jabba the Hutt.

Little does Luke know that the GALACTIC EMPIRE has secretly begun construction on a new armored space station even more powerful than the first dreaded Death Star.

When completed, this ultimate weapon will spell certain doom for the small band of Rebels struggling to restore freedom to the galaxy . . .

Pan down to reveal a monstrous half-completed Death Star, its massive superstructure curling away from the completed section like the arms of a giant octopus. Beyond, in benevolent contrast, floats the small, green Moon of Endor

An Imperial Star Destroyer moves overhead toward the massive armored space station, followed by two zipping TIE fighters. A small Imperial shuttle rockets from the main bay of the ship and hustles toward the Death Star.

INTERIOR: IMPERIAL SHUTTLE—COCKPIT

The shuttle captain makes contact with the Death Star.

SHUTTLE CAPTAIN: Command station, this is ST 321. Code Clearance Blue. We're starting our approach. Deactivate the security shield.

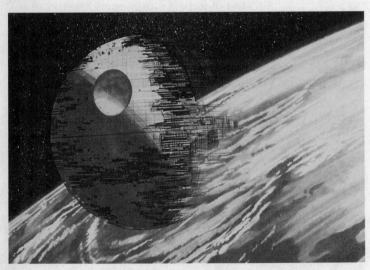

DEATH STAR CONTROLLER: *(filtered voice-over)* The security deflector shield will be deactivated when we have confirmation of your code transmission. Stand by. . . . You are clear to proceed.

SHUTTLE CAPTAIN: We're starting our approach.

INTERIOR: DEATH STAR CONTROL ROOM

Operators move about among the control panels. A shield operator hits switches beside a large screen, on which is a display of the Death Star, the moon of Endor, and a bright web delineating the invisible deflector shield.
 A control officer rushes over to the shield operator.

OFFICER: Inform the commander that Lord Vader's shuttle has arrived.

OPERATOR: Yes, sir.

The control officer moves to a view port and watches as the Imperial shuttle lands in the massive docking bay. A squad of Imperial stormtroopers move into formation before the craft.

INTERIOR: DEATH STAR—MAIN DOCKING BAY

The Death Star commander, Moff Jerjerrod, a tall, confident technocrat, strides through the assembled troops to the base of the shuttle ramp. The troops snap to attention; many are uneasy about the new arrival. But the Death Star commander stands arrogantly tall.
 The exit hatch of the shuttle opens with a whoosh, revealing only darkness. Then, heavy footsteps and mechanical breathing. From this black void appears Darth Vader, Lord of the Sith. Vader looks over the assemblage as he walks down the ramp.

JERJERROD: Lord Vader, this is an unexpected pleasure. We're honored by your presence.

VADER: You may dispense with the pleasantries. Commander, I'm here to put you back on schedule.

The commander turns ashen and begins to shake.

JERJERROD: I assure you, Lord Vader, my men are working as fast as they can.

VADER: Perhaps I can find new ways to motivate them.

JERJERROD: I tell you, this station will be operational as planned.

VADER: The Emperor does not share your optimistic appraisal of the situation.

JERJERROD: But he asks the impossible. I need more men.

VADER: Then perhaps you can tell him when he arrives.

JERJERROD: *(aghast)* The Emperor's coming here?

VADER: That is correct, Commander. And he is most displeased with your apparent lack of progress.

JERJERROD: We shall double our efforts.

VADER: I hope so, Commander, for your sake. The Emperor is not as forgiving as I am.

WIPE TO:

EXTERIOR: ROAD TO JABBA'S PALACE—TATOOINE

A lonely, windswept road meanders through the desolate Tatooine terrain. We hear a familiar beeping and a distinctive reply before catching sight of Artoo-Detoo and See-Threepio,

making their way along the road toward the ominous palace of Jabba the Hutt.

THREEPIO: Of course I'm worried. And you should be, too. Lando Calrissian and poor Chewbacca never returned from this awful place.

Artoo whistles timidly.

THREEPIO: Don't be so sure. If I told you half the things I've heard about this Jabba the Hutt, you'd probably short-circuit.

The two droids fearfully approach the massive gate to the palace.

THREEPIO: Artoo, are you sure this is the right place? I better knock, I suppose.

EXTERIOR: JABBA'S PALACE—GATE

Threepio looks around for some kind of signaling device, then timidly knocks on the iron door.

THREEPIO: *(instantly)* There doesn't seem to be anyone there. Let's go back and tell Master Luke.

A small hatch in the middle of the door opens and a spidery mechanical arm, with a large electronic eyeball on the end, pops out and inspects the two droids.

STRANGE VOICE: Tee chuta hhat yudd!

THREEPIO: Goodness gracious me!

Threepio points to Artoo, then to himself.

THREEPIO: Artoo Detoowha bo Seethreepiowha ey toota odd mischka Jabba du Hutt.

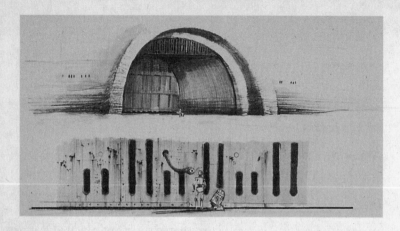

The eye looks from one robot to the other, there is a laugh, then the eye zips back into the door. The hatch slams shut. Artoo beeps his concern.

THREEPIO: I don't think they're going to let us in, Artoo. We'd better go.

Artoo beeps his reluctance as Threepio turns to leave. Suddenly, the massive door starts to rise with a horrific metallic screech. The robots turn back and face an endless black cavity. The droids look at one another, afraid to enter.

Artoo starts forward into the gloom. Threepio rushes after his stubby companion. The door lowers noisily behind them.

THREEPIO: Artoo, wait. Oh, dear! Artoo. Artoo, I really don't think we should rush into all this.

Artoo continues down the corridor, with Threepio following.

THREEPIO: Oh, Artoo! Artoo, wait for me!

INTERIOR: JABBA'S PALACE—HALLWAY

The door slams shut with a loud crash that echoes throughout the dark passageway. The frightened robots are met by two

giant, green Gamorrean guards, who fall in behind them. Threepio glances quickly back at the two lumbering brutes, then back to Artoo. One guard grunts an order. Artoo beeps nervously.

THREEPIO: Just you deliver Master Luke's message and get us out of here. Oh, my! Oh! Oh, no.

Walking toward them out of the darkness is Bib Fortuna, a humanlike alien with long tentacles protruding from his skull.

BIB: Die Wanna Wanga!

THREEPIO: Oh, my! Die Wanna Wauaga. We—we bring a message to your master, Jabba the Hutt.

Artoo lets out a series of quick beeps.

THREEPIO: *(continues)* . . . and a gift. *(thinks a moment, then to Artoo)* Gift, what gift?

Bib shakes his head negatively.

BIB: Nee Jabba no badda. Me chaade su goodie.

Bib holds out his hand toward Artoo and the tiny droid backs up a bit, letting out a protesting array of squeaks. Threepio turns to the strange-looking alien.

THREEPIO: He says that our instructions are to give it only to Jabba himself.

Bib thinks about this for a moment.

THREEPIO: I'm terribly sorry. I'm afraid he's ever so stubborn about these sorts of things.

Bib gestures for the droids to follow.

BIB: Nudd Chaa.

The droids follow the tall, tentacled alien into the darkness, trailed by the two guards.

THREEPIO: Artoo, I have a bad feeling about this.

INTERIOR: JABBA'S THRONE ROOM

The throne room is filled with the vilest, most grotesque creatures ever conceived in the universe. Artoo and Threepio seem very small as they pause in the doorway to the dimly lit chamber.

Light shafts partially illuminate the drunken courtiers as Bib Fortuna crosses the room to the platform upon which rests the leader of this nauseating crowd: Jabba the Hutt. The monarch of the galactic underworld is a repulsive blob of bloated fat with a maniacal grin. Chained to the horrible creature is the beautiful alien female dancer named Oola. At the foot of the dais sits an obnoxious birdlike creature, Salacious Crumb. Bib whispers something in the slobbering degenerate's ear. Jabba laughs, horribly, at the two terrified droids before him. Threepio bows politely.

THREEPIO: Good morning.

JABBA: Bo Shuda!

The robots jump forward to stand before the repulsive, loose-skinned villain.

THREEPIO: The message, Artoo, the message.

Artoo whistles, and a beam of light projects from his domed head, creating a hologram of Luke on the floor. The image grows to over ten feet tall, and the young Jedi towers over the space gangsters.

LUKE: Greetings, Exalted One. Allow me to introduce myself. I am Luke Skywalker, Jedi Knight and friend to Captain Solo. I

know that you are powerful, mighty Jabba, and that your anger with Solo must be equally powerful. I seek an audience with Your Greatness to bargain for Solo's life. *(Jabba's crowd laughs.)* With your wisdom, I'm sure that we can work out an arrangement which will be mutually beneficial and enable us to avoid any unpleasant confrontation. As a token of my goodwill, I present to you a gift: these two droids.

Threepio is startled by this announcement.

THREEPIO: What did he say?

LUKE: *(continues)* . . . Both are hardworking and will serve you well.

THREEPIO: This can't be! Artoo, you're playing the wrong message.

Luke's hologram disappears. Jabba laughs while Bib speaks to him in Huttese.

JABBA: *(in Huttese subtitled)* There will be no bargain.

THREEPIO: We're doomed.

JABBA: *(in Huttese, subtitled)* I will not give up my favorite decoration. I like Captain Solo where he is.

Jabba laughs hideously and looks toward an alcove beside the throne. Hanging high, flat against the wall, exactly as we saw him last, is a carbonized Han Solo.

THREEPIO: Artoo, look! Captain Solo. And he's still frozen in carbonite.

INTERIOR: DUNGEON CORRIDOR

One of Jabba's Gamorrean guards marches Artoo and Threepio down a dank, shadowy passageway lined with holding cells. The cries of unspeakable creatures bounce off the cold stone

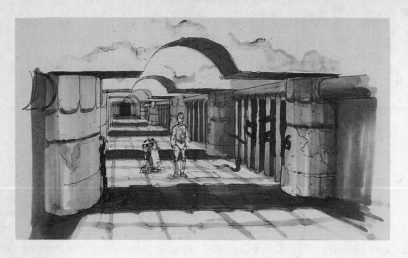

walls. Occasionally a repulsive arm or tentacle grabs through the bars at the hapless droids. Artoo beeps pitifully.

THREEPIO: What could possibly have come over Master Luke. Is it something I did? He never expressed any unhappiness with my work. Oh! Oh! Hold it! Ohh!

A large tentacle wraps around Threepio's neck. He manages to break free, and they move on to a door at the end of the corridor.

INTERIOR: BOILER ROOM

The door slides open, revealing a room filled with steam and noisy machinery. The guard motions them into the boiler room, where they are met by a tall, thin humanlike robot named EV-9D9 (Eve-Ninedenine). Behind the robot can be seen a torture rack pulling the legs off of a screaming baby work droid. A second power droid is upside down. As smoking branding irons are pressed into his feet, the stubby robot lets out an

agonized electronic scream. Artoo and Threepio cringe as the guard grunts to EV-9D9.

NINEDENINE: Ah, good. New acquisitions. You are a protocol droid, are you not?

THREEPIO: I am See-Threepio, human-cy—

NINEDENINE: Yes or no will do.

THREEPIO: Oh. Well, yes.

NINEDENINE: How many languages do you speak?

THREEPIO: I am fluent in over six million forms of communication, and can readily—

NINEDENINE: Splendid! We have been without an interpreter since our master got angry with our last protocol droid and disintegrated him.

THREEPIO: Disintegrated?

NINEDENINE: *(to a Gamorrean guard)* Guard! This protocol droid might be useful. Fit him with a restraining bolt and take him back to His Excellency's main audience chamber.

The guard shoves Threepio toward the door.

THREEPIO: *(disappearing)* Artoo, don't leave me! Ohhh!

Artoo lets out a plaintive cry as the door closes. Then he beeps angrily.

NINEDENINE: You're a feisty little one, but you'll soon learn some respect. I have need for you on the master's sail barge. And I think you'll fill in nicely.

The poor work droid in the background lets out another tortured electronic scream.

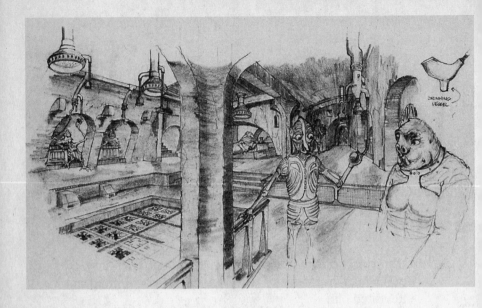

INTERIOR: JABBA'S THRONE ROOM

The court of Jabba the Hutt is in the midst of a drunken, raucous party. Sloppy, smelly monsters cheer and make rude noises as Oola and a fat female dancer perform in front of Jabba's throne.

Jabba leers at the dancers and with a lustful gleam in his eye beckons Oola to come and sit with him. She stops dancing and backs away, shaking her head. Jabba gets angry and points to a spot next to him.

JABBA: Da Eitha!

The lovely alien shakes her head again and screams.

OOLA: Na Chuba negatorie Na! Na! Natoota . . .

Jabba is furious and pulls her toward him, tugging on the chain.

JABBA: Boscka!

He pushes a button and, before the dancer can flee, a trap door in the floor springs open and swallows her up. As the door snaps shut, a muffled growl is followed by a hideous scream. Jabba and his monstrous friends laugh hysterically and several revelers hurry over to watch her fate through a grate.

Threepio cringes and glances wistfully at the carbonite form of Han Solo, but is immediately distracted by a gunshot offscreen. An unnatural quiet sweeps the boisterous gathering. On the far side of the room, the crush of debauchers move aside to allow the approach of two guards followed by Boushh, an oddly cloaked bounty hunter, leading his captive, Han Solo's copilot, Chewbacca the Wookiee.

Bib takes his place next to his disgusting master, and whispers into his ear, pointing at Chewbacca and the bounty hunter. Jabba listens intently, then the bounty hunter bows before the gangster and speaks a greeting in a strange, electronically processed tongue (Ubese).

BOUSHH: *(in Ubese subtitled)* I have come for the bounty on this Wookiee.

THREEPIO: Oh, no! Chewbacca!

JABBA: *(in Huttese subtitled)* At last we have the mighty Chewbacca.

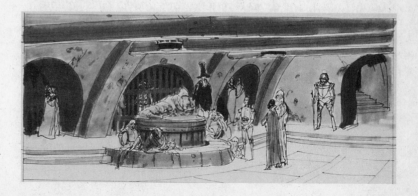

Jabba lets out a loud, long, blood-curdling laugh and turns to Threepio, waving him closer. The reluctant droid obeys.

THREEPIO: Oh, uh, yes, uh, I am here, Your Worshipfulness. Uh . . . yes!

Jabba continues speaking, as Threepio nervously translates. Boushh listens, studying the dangerous creatures around the room. He notices Boba Fett standing near the door.

THREEPIO: Oh. The illustrious Jabba bids you welcome and will gladly pay you the reward of twenty-five thousand.

BOUSHH: *(in Ubese subtitled)* I want fifty thousand. No less.

THREEPIO: Fifty thousand. No less.

Jabba immediately flies into a rage, knocking the golden droid off the raised throne into a clattering heap on the floor. Boushh adjusts his weapon as Jabba raves in Huttese and Threepio struggles back onto the throne. The disheveled droid tries to compose himself.

THREEPIO: Uh, oh . . . but what, what did I say? *(to Boushh)* Uh, the mighty Jabba asks why he must pay fifty thousand.

The bounty hunter holds up a small silver ball in his hand. Threepio looks at it, then looks at Jabba, then back to the bounty hunter. The droid is very nervous and Jabba is getting very impatient.

THREEPIO: Because he's holding a thermal detonator.

The guards instantly back away, as do most of the other monsters in the room. Jabba stares at the silver ball, which begins to glow in the bounty hunter's hand. The room has fallen into a tense hush. Jabba stares at the bounty hunter malevolently until a sly grin creeps across his vast mouth and he begins to laugh.

JABBA: *(in Huttese subtitled)* This bounty hunter is my kind of scum. Fearless and inventive.

Jabba continues.

THREEPIO: Jabba offers the sum of thirty-five. And I do suggest you take it.

Bib and the other monsters study the bounty hunter and wait for his reaction. Boushh releases a switch on the thermal detonator and it goes dead.

BOUSHH: Zeebuss.

THREEPIO: He agrees!

The raucous crowd of monsters erupts in a symphony of cheers and applause as the party returns to its full noisy pitch. Chewbacca growls. As he is lead away we spot Lando Calrissian, disguised as a skiff guard in a partial face mask. The band starts up and dancing girls take the center of the floor, to the hoots of the loudly appreciative creatures.

Boushh leans against a column with gunfighter cool and surveys the scene, his gaze stopping only when it connects with a glare from across the room. Boba Fett is watching him. Boushh shifts slightly, cradling his weapon lovingly. Boba Fett shifts with equally ominous arrogance.

INTERIOR: DUNGEON CORRIDOR AND CELL

Gamorrean guards lead Chewie down the same hallway we saw before. When a tentacle reaches out at the Wookiee, Chewie's ferocious roar echoes against the walls and the tentacle snaps back into its cell in terror. It takes all the guards to hurl Chewie roughly into a cell, slamming the door behind him. Chewie lets out a pathetic howl and bangs on the iron door.

EXTERIOR: JABBA'S PALACE

The palace is sitting in the light of the double sunset. On the road in front, a large toadlike creature flicks its tongue out for a desert rodent, and burps in satisfaction.

WIPE TO:

JABBA'S THRONE ROOM—NIGHT

Silence. The room is deserted, only the awful debris of the alien celebration giving mute witness to the activity here before. Several drunk creatures lie unconscious around the room, snoring loudly.

A shadowy figure moves stealthily among the columns at the perimeter of the room and is revealed to be Boushh, the bounty hunter. He picks his way carefully through the snoring, drunken monsters.

Han Solo, the frozen space pirate, hangs spotlighted on the wall, his coffinlike case suspended by a force field. The bounty hunter deactivates the force field by flipping a control switch to one side of the coffin. The heavy case slowly lowers to the floor of the alcove.

Boushh steps up to the case, studying Han, then turns to the controls on the side of the coffin. He activates a series of switches and, after one last, hesitant look at Han, slides the decarbonization lever. The case begins to emit a sound as the hard shell covering the contours of Han's face begins to melt away. The bounty hunter watches as Han's body is freed of its metallic coat and his forearms and hands, previously raised in reflexive protest, drop slackly to his side. His face muscles relax from their mask of horror. He appears quite dead.

Boushh's ugly helmet leans close to Han's face listening for the breath of life. Nothing. He waits. Han's eyes pop open with a

*start and he begins coughing. The bounty hunter steadies the
staggering newborn.*

BOUSHH: Just relax for a moment. You're free of the carbonite.

Han touches his face with his hand and moans.

BOUSHH: Shhh. You have hibernation sickness.

HAN: I can't see.

BOUSHH: Your eyesight will return in time.

HAN: Where am I?

BOUSHH: Jabba's palace.

HAN: Who are you?

*The bounty hunter reaches up and lifts the helmet from his
head, revealing the beautiful face of Princess Leia.*

LEIA: Someone who loves you.

HAN: Leia!

LEIA: I gotta get you out of here.

19

As Leia helps her weakened lover to stand up, the relative quiet is pierced by an obscene Huttese cackle from the other side of the alcove.

HAN: What's that? I know that laugh.

The curtain on the far side of the alcove opens, revealing Jabba the Hutt, surrounded by Bib and other aliens. He laughs again, and his gross cronies join in a cacophony of alien glee.

HAN: Hey, Jabba. Look, Jabba, I was just on my way to pay you back, but I got a little sidetracked. It's not my fault.

Jabba laughs.

JABBA: *(in Huttese subtitled)* It's too late for that, Solo. You may have been a good smuggler, but now you're bantha fodder.

HAN: Look—

JABBA: *(continues, in Huttese subtitled)* Take him away!

The guards grab Han and start to lead him away.

HAN: Jabba . . . I'll pay you triple! You're throwing away a fortune here. Don't be a fool!

Han is dragged off, as Lando quickly moves forward and attempts to lead Leia away.

JABBA: *(in Huttese subtitled)* Bring her to me.

Jabba chuckles as Lando and a second guard drag the beautiful young princess toward him. Threepio peeks from behind a monster and quickly turns away in disgust.

LEIA: We have powerful friends. You're gonna regret this . . .

JABBA: *(in Huttese subtitled)* I'm sure.

Inexorably her lovely face moves to within a few inches of Jabba's ugly blob of a head, and Leia turns away in disgust.

LEIA: Ugh!

THREEPIO: Ohhh, I can't bear to watch.

INTERIOR: DUNGEON CELL

The heavy metal door of the dungeon whines and slowly creaks open. A guard throws the blinded star captain into the dark cell and the door slams shut behind him, leaving only a thin sliver of light from a crack in the door. Han is trying to collect himself when suddenly a growl is heard from the far side of the cell. He jumps back against the cell door and listens.

HAN: Chewie? Chewie, is that you?

The shadowy figure lets out a crazy yell and races toward Han, lifting him off the ground with a big hug that carries them into the light, revealing Chewie.

HAN: Ah! Chew—Chewie!

The giant Wookiee barks with glee.

HAN: Wait. I can't see, pal. What's goin' on?

Chewie barks an excited blue streak.

HAN: Luke? Luke's crazy. He can't even take care of himself, much less rescue anybody.

Chewie barks a reply.

HAN: A—a Jedi Knight? I—I'm out of it for a little while, everybody gets delusions of grandeur.

Chewie growls insistently. He holds Han to his chest and pets his head.

21

HAN: I'm all right, pal. I'm all right.

FADE OUT.

INTERIOR: MAIN GATE AND HALL—JABBA'S PALACE

Noisily, the main gate lifts to flood the blackness with blinding light and reveals the silhouetted figure of Luke Skywalker. He is clad in a robe similar to Ben's and wears neither pistol nor laser sword. Luke strides purposefully into the hallway. Two giant guards move to block Luke's path. Luke halts.

Luke raises his hand and points at the puzzled guards, who immediately lower their spears and fall back. The young Jedi lowers his hand and moves on down the hallway.

Bib Fortuna appears out of the gloom. He speaks to Luke as they approach each other, but Luke doesn't stop and Bib must reverse his direction and hurry alongside the young Jedi in order to carry on the conversation. Several other guards fall in behind them in the darkness.

LUKE: I must speak with Jabba.

Bib answers in Huttese, shaking his head in denial. Luke stops and stares at Bib; he raises his hand slightly.

LUKE: You will take me to Jabba now!

Bib turns in hypnotic response to Luke's command, and Luke follows him into the gloom.

LUKE: You serve your master well.

Bib responds.

LUKE: And you will be rewarded.

INTERIOR: JABBA'S THRONE ROOM

Jabba is asleep on his throne, with Leia lying in front of him. Salacious sits by Jabba's tail, watching it wriggle. Leia is now dressed in the skimpy costume of a dancing girl; a chain runs from a manacle/necklace at her throat to her new master, Jabba the Hutt. Threepio stands behind Jabba as Bib comes up to the gangster slug.

THREEPIO: At last! Master Luke's come to rescue me.

BIB: Master.

Jabba awakens with a start and Bib continues, in Huttese.

BIB: . . . Luke Skywalker, Jedi Knight.

JABBA: *(in Huttese subtitled)* I told you not to admit him.

LUKE: I must be allowed to speak.

BIB: *(in Huttese subtitled)* He must be allowed to speak.

Jabba, furious, clobbers Bib and shoves him away.

JABBA: *(in Huttese subtitled)* You weak-minded fool! He's using an old Jedi mind trick.

Luke stares hard at Jabba.

LUKE: You will bring Captain Solo and the Wookiee to me.

JABBA: *(in Huttese subtitled)* Your mind powers will not work on me, boy.

LUKE: Nevertheless, I'm taking Captain Solo and his friends. You can either profit by this . . . or be destroyed! It's your choice. But I warn you not to underestimate my powers.

Jabba's laugh is mean and loud. Threepio attempts to warn Luke about the pit.

THREEPIO: Master Luke, you're standing on . . .

JABBA: *(in Huttese subtitled)* There will be no bargain, young Jedi. I shall enjoy watching you die.

Luke reaches out, and a pistol jumps out of a guard's holster and flies into Luke's hand. The bewildered guard grabs for it as Jabba raises his hand.

JABBA: Boscka!

The floor suddenly drops away, sending Luke and the hapless guard into the pit. The pistol goes off, blasting a hole in the ceiling. Jabba laughs and his courtiers join in. Leia starts forward but is restrained by a human guard—Lando, recognizable behind his mask. She looks at him and he shakes his head "no."

INTERIOR: RANCOR PIT

Luke and the guard have dropped twenty-five feet from a chute into the dungeonlike cage. Luke gets to his feet as the guard yells hysterically for help. A crowd gathers up around the edge of the pit as a door in the side of the pit starts to rumble open. The guard screams in panic. Luke looks calmly around for a means of escape.

THREEPIO: Oh, no! The rancor!

At the side of the pit, an iron door rumbles upward and a giant, fanged rancor emerges. The guard runs to the side of the pit and tries futilely to scramble to the top. The hideous beast closes in on him.

The rancor moves past Luke, and as the guard continues to scramble, the rancor picks him up and pops him into its slavering jaws. A few screams, and the guard is swallowed with a gulp. The audience cheers and laughs at the guard's fate.

The monster turns and starts for Luke. The young Jedi dashes away just ahead of the monster's swipe at him, and picks up the long arm bone of an earlier victim. The monster grabs Luke and brings him up to his salivating mouth. At the last moment, Luke wedges the bone in the monster's mouth and is dropped to the floor. The monster bellows in rage and flails about, hitting the side of the pit, causing an avalanche.

The monster crunches the bone in its jaws and sees Luke, who squeezes into a crevice in the pit wall. Luke looks past the monster to the holding cave beyond. On the far side of the holding cave is a utility door—if only he can get to it. The rancor spots Luke and reaches into the crevice for him. Luke grabs a large rock and raises it, smashing it down on the rancor's finger.

HOLDING TUNNEL—RANCOR PIT

The rancor lets out a loud howl as Luke makes a run for the holding cave. He reaches the door and pushes a button to open it. When he succeeds, he sees a heavy barred gate between him and safety. Beyond the gate two guards look up from their dinner. Luke turns to see the monster heading for him, and pulls with all his might on the gate. The guards move to the gate and start poking at the young Jedi with spears, laughing.

Luke crouches (against the wall) as the monster starts to reach for him. Suddenly he notices a main door control panel

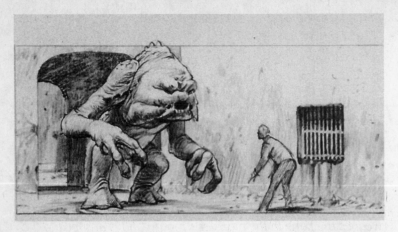

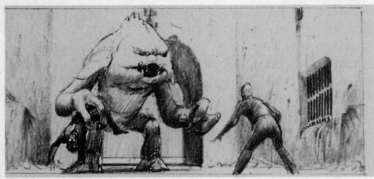

halfway up the wall. As the rancor moves in for the kill, Luke picks up a skull from the cave floor and hurls it at the panel. A split second before the rancor reaches Luke, the panel explodes. The giant overhead door comes crashing down on the beast's head, squashing it like a sledgehammer on an egg.

INTERIOR: THRONE ROOM

A startled gasp is heard from the stunned court. There's consternation at this turn of events. Heads look to Jabba,

who is actually turning red with anger. Leia cannot suppress her joy. Jabba utters harsh commands to his guards and they hurry off.

JABBA: *(in Huttese subtitled)* Bring me Solo and the Wookiee. They will all suffer for this outrage.

INTERIOR: RANCOR PIT

The rancor keepers have come into the cage and are examining their dead beast. One of them breaks down and weeps. The other glares menacingly at Luke, who is unworried. Several guards rush into the holding tunnel and take Luke away.

INTERIOR: THRONE ROOM

The crowd of creepy courtiers parts as Han and Chewie are brought into the throne room, and other guards drag Luke up the steps.

LUKE: Han!

HAN: Luke!

LUKE: Are you all right?

HAN: Fine. Together again, huh?

LUKE: Wouldn't miss it.

HAN: How are we doing?

LUKE: The same as always.

HAN: That bad, huh? Where's Leia?

Luke looks to Leia.

LEIA: I'm here.

Threepio is standing behind the grotesque gangster as he strokes Leia like a pet cat. Several of the guards, including Lando, bring Luke from the other side of the room. Boba is standing behind Jabba.

Threepio steps forward and translates for the captives.

THREEPIO: Oh, dear. His High Exaltedness, the great Jabba the Hutt, has decreed that you are to be terminated immediately.

HAN: Good, I hate long waits.

THREEPIO: You will therefore be taken to the Dune Sea and cast into the Pit of Carkoon, the nesting place of the all-powerful Sarlacc.

HAN: *(to Luke)* Doesn't sound so bad.

THREEPIO: In his belly, you will find a new definition of pain and suffering, as you are slowly digested over a thousand years.

HAN: On second thought, let's pass on that, huh?

Chewie barks his agreement.

LUKE: You should have bargained, Jabba. That's the last mistake you'll ever make.

Jabba cackles evilly at this.

As the guards drag the prisoners from the throne room, a loud cheer rises from the crowd. Leia and Chewie exchange concerned looks, but Luke Skywalker, Jedi warrior, cannot suppress a smile.

EXTERIOR: TATOOINE DUNE SEA—SKIFF

Jabba's huge sail barge moves above the desert surface accompanied by two smaller skiffs. One of the skiffs glides close,

revealing Luke, Han, and Chewie—all in bonds—surrounded by guards, one of whom is Lando in disguise.

HAN: I think my eyes are getting better. Instead of a big dark blur, I see a big light blur.

LUKE: There's nothing to see. I used to live here, you know.

HAN: You're gonna die here, you know. Convenient.

LUKE: Just stick close to Chewie and Lando. I've taken care of everything.

HAN: Oh . . . great!

INTERIOR: BARGE OBSERVATION DECK

Jabba the Hutt rides like a sultan in the massive antigravity ship. His entire retinue is with him, drinking, eating, and having a good time. Leia is watching her friends in the skiff when the chain attached to her neck is pulled tight and Jabba tugs the scantily clad princess to him.

JABBA: *(in Huttese subtitled)* Soon you will learn to appreciate me.

Threepio wanders among the sail barge aliens, bumping into a smaller droid serving drinks, spilling them all over the place. The stubby droid lets out an angry series of beeps and whistles.

THREEPIO: Oh, I'm terribly sor . . . Artoo! What are you doing here?

Artoo beeps a quick reply.

THREEPIO: Well, I can see you're serving drinks, but this place is dangerous. They're going to execute Master Luke and, if we're not careful, us too!

Artoo whistles a singsong response.

THREEPIO: Hmm. I wish I had your confidence.

EXTERIOR: SARLACC PIT

The convoy moves up over a huge sand pit. The sail barge stops to one side of the depression, as does the escort skiff. But the prisoners' skiff moves out directly over the center and hovers. At the bottom of the deep cone of sand is a repulsive, mucous-lined hole, surrounded by thousands of needle-sharp teeth. This is the Sarlacc. A plank is extended from the edge of the prisoners' skiff. Guards release Luke's bonds and shove him out onto the plank above the Sarlacc's mouth.

INTERIOR: SAIL BARGE OBSERVATION DECK

Jabba and Leia are now by the rail, watching. Threepio leans forward and the slobbering villain mumbles something to him. As Threepio steps up to a comlink, Jabba raises his arm and the motley array of intergalactic pirates fall silent. Threepio's voice is amplified across loudspeakers.

THREEPIO: Victims of the almighty Sarlacc: His Excellency hopes that you will die honorably. But should any of you wish to beg for mercy, the great Jabba the Hutt will now listen to your pleas.

EXTERIOR: SKIFF

Han steps forward arrogantly and begins to speak.

HAN: Threepio, you tell that slimy piece of . . . worm-ridden filth he'll get no such pleasure from us. Right?

Chewie growls his agreement.

LUKE: Jabba! This is your last chance. Free us or die.

Lando moves unobtrusively along the skiff as Luke shoots a quick look of conspiracy at him.

INTERIOR: SAIL BARGE OBSERVATION DECK

The assembled monsters rock with mocking laughter as Artoo zips unnoticed up the ramp to the upper deck. Jabba's laughter subsides as he speaks into the comlink.

JABBA: *(in Huttese subtitled)* Move him into position.

Jabba makes a thumbs-down gesture. Leia looks worried.

EXTERIOR: BARGE—UPPER DECK

Artoo appears from below and zips over to the rail facing the pit. Below, in the skiff, Luke is prodded by a guard to the edge of the plank over the gaping Sarlacc. Luke looks up at Artoo, then gives a jaunty salute: the signal the little droid has been waiting for. A flap opens in Artoo's domed head.

JABBA: *(in Huttese subtitled)* Put him in.

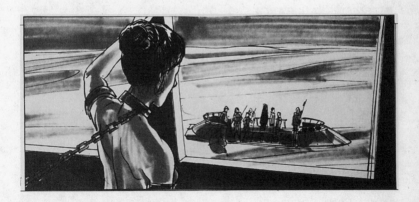

EXTERIOR: SKIFF—PLANK

Luke is prodded and jumps off the plank to the cheers of the bloodthirsty spectators. But, before anyone can even perceive what is happening, he spins around and grabs the end of the plank by his fingertips. The plank bends wildly from his weight and catapults him skyward. In midair he does a complete flip and drops down on the end of the plank in the same spot he just vacated, but facing the skiff. He casually extends an open palm and—his lightsaber, which Artoo has sent arcing toward him, drops into his hand.

With samurai speed, Luke ignites it and attacks the guard who prodded him off the plank, sending the hapless monster screaming overboard. The other guards swarm toward Luke. He wades into them, lightsaber flashing. Lando struggles with another guard at the back of the skiff.

EXTERIOR: SARLACC PIT

A bewildered guard lands in the soft, sandy slope of the pit, and begins sliding. He claws desperately as a Sarlacc tentacle grabs him and pulls him screaming into the viscous mouth.

INTERIOR: SAIL BARGE

Jabba watches this and explodes in rage. He barks commands, and the guards around him rush off to do his bidding. The scuzzy creatures watching the action from the window are in an uproar.

EXTERIOR: SKIFF

Luke knocks another guard off the skiff and into the waiting mouth of the Sarlacc. He starts to untie Chewie's bonds.

LUKE: Easy, Chewie.

At that moment, the deck gunmen on the barge unleash a series of blasts from a big cannon on the upper deck. Lando is tossed from the deck of the rocking skiff. He manages to grab a rope, and dangles desperately above the Sarlacc pit.

LANDO: Whoa! Whoa! Help!

EXTERIOR: UPPER DECK—SAIL BARGE

With two swift strides, the dangerous Boba Fett ignites his rocket pack, leaps into the air, and flies from the barge down to the skiff.

EXTERIOR: SKIFF

Boba lands on the skiff and starts to aim his laser gun at Luke, who has freed Han and Chewie from their bonds. But before Boba can fire, the young Jedi spins on him, lightsaber sweeping, and hacks the bounty hunter's gun in half.

Immediately, the skiff takes another direct hit from the barge's deck gun. Shards of skiff deck fly. Chewie and Han are thrown against the rail.

HAN: Chewie, you okay? Where is he?

The Wookiee is wounded and he howls in pain.

HAN: I'm okay, pal.

For a moment, Luke is distracted, and in that moment, Boba fires a cable out of his armored sleeve. Instantly, Luke is wrapped in a strong cable, his arms pinned against his side, his sword arm free only from the wrist down. Luke bends his wrist so the lightsaber points straight up to reach the wire lasso and cuts through. Luke shrugs away the cable and stands free.

Another blast from the barge's deck gun hits near Boba and he is knocked unconscious to the deck, next to where Lando is hanging.

33

STAR WARS

LANDO: Han! Chewie?

HAN: Lando!

Luke is a little shaken but remains standing as a fusillade brackets him. The second skiff, loaded with guards firing their weapons, moves in on Luke fast. Luke leaps toward the incoming second skiff. The young Jedi leaps into the middle of the second skiff and begins decimating the guards from their midst.

Chewie, wounded, tries to lift himself as he barks directions to Han, guiding him toward a spear that has been dropped by one of the guards. Han searches the deck as Chewie barks directions; finally he grabs hold of the spear.

Boba Fett, badly shaken, rises from the deck. He looks over at the other skiff, where Luke is whipping a mass of guards. Boba raises his arm and aims his lethal appendage.

Chewie barks desperately at Han.

HAN: Boba Fett?! Boba Fett?! Where?

The space pirate turns around blindly, and the long spear in his hand whacks squarely in the middle of Boba's rocket pack.

The impact of the swing causes the rocket pack to ignite. Boba blasts off, flying over the second skiff like a missile, smashing against the side of the huge sail barge and sliding away into the pit. He screams as his armored body makes its last flight past Lando and directly into the mucous mouth of the Sarlacc. The Sarlacc burps. Chewie growls a weak congratulations to Han.

INTERIOR: SAIL BARGE

Leia turns from the spectacle outside, leaps onto Jabba's throne, and throws the chain that enslaves her over his head around his bulbous neck. Then she dives off the other side of the throne, pulling the chain violently in her grasp. Jabba's flaccid neck contracts beneath the tightening chain. His huge eyes bulge

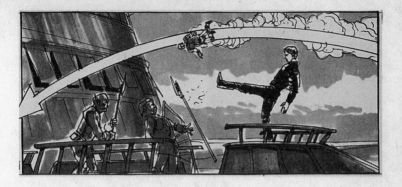

*from their sockets and his scum-coated tongue flops out. The
Exalted Hutt's huge tail spasms through its death throes and
then slams down into final stillness. Leia struggles to free herself
of her bondage.*

EXTERIOR: SKIFF

*Luke continues to destroy the aliens on the guards' skiff, as Han
extends his spear downward to Lando, who is still dangling
precariously from a rope on the prisoners' skiff.*

HAN: Lando, grab it!

LANDO: Lower it!

HAN: I'm trying!

*A major hit from the barge deck gun knocks the skiff on its side.
Han and almost everything else on board slides overboard. The
rope breaks, and Lando falls to the side of the Sarlacc pit.
Luckily, Han's foot catches on the skiff railing and he dangles
above Lando and the pit. The wounded Wookiee holds onto the
skiff for dear life as another hit from the deck gun rocks the skiff
violently.*

HAN: Whoa! Whoa! Whoa! Grab me, Chewie! I'm slipping.

Chewie grabs hold of Han's feet, holding him upside down, as Han extends the spear toward Lando, who is clutching to the side of the pit.

HAN: Grab it! L-Lando. Grab!

Luke finishes off the last guard on the second skiff. He sees the deck gun blasting away at his helpless companions. Luke leaps from the skiff, across a chasm of air, to the sheer metallic side of the sail barge. Barely able to get a fingerhold, he begins a painful climb up the hull, when suddenly an ax smashes through a window an inch from his head. With Jedi agility, Luke grasps the wrist holding the ax and yanks the helpless guard through the broken window and into the deadly pit.

The injured Chewie is reaching over the rail for the dangling Han, who is, in turn, blindly reaching down toward the desperate Lando. The Baron has stopped his slippage down the sandy slope of the Sarlacc pit by lying very still. Every time he tries to reach for Han, the loose sand moves him closer to his final reward.

HAN: Grab it! Almost. . . . You almost got it!

Another blast hits the front of the tilted skiff, causing Lando to let go of the spear.

LANDO: Hold it! Whoa!

Again Han extends the spear toward Lando.

HAN: Gently now. All . . . all right. Now easy, easy. Hold me, Chewie.

Lando screams. One of the Sarlacc's tentacles has wrapped tightly around his ankle, dragging him down the side of the pit.

HAN: Chewie! Chewie, give me the gun. Don't move, Lando.

LANDO: No, wait! I thought you were blind!

HAN: It's all right. Trust me. Don't move.

LANDO: All right! A little higher! Just a little higher!

Han adjusts his aim as Lando lowers his head, and the fuzzy-eyed pirate fires at the tentacle. Direct hit. The tentacle releases Lando, and Chewie starts to pull them on board the skiff.

HAN: Chewie, pull us up! Come on! Okay . . . up, Chewie, up!

EXTERIOR: UPPER DECK

The deck gunners have Chewie and the desperate dangling human chain in their gun sights when something up on deck commands their attention: Luke, standing before them like a pirate king, ignites his lightsaber. The deck gunners have barely reached for their pistols before the young Jedi has demolished them. Immediately, Luke turns to see two more gunners (who have been uncovering a giant gun at the end of the barge) racing for him, firing their laser pistols.

INTERIOR: SAIL BARGE—OBSERVATION DECK

Leia is struggling against her chains in desperation as Artoo zips through the tumult of confused monsters to the rescue; the stubby little droid extends a small laser gun and blasts the chain apart.

LEIA: Come on. We gotta get out of here quick.

Artoo and Leia race for the exit, passing Threepio, who is kicking and screaming as Salacious Crumb, the reptilian monkey-monster, picks out one of the golden droid's eyes.

THREEPIO: Not my eyes! Artoo, help! Quickly, Artoo. Oh! Ohhh! You beast!

Artoo zips over and zaps Salacious, sending him skyward with a scream, crashing into the rafters as Artoo, Leia, and Threepio (with his eye dangling from a wire) hurry off.

EXTERIOR: UPPER DECK—SAIL BARGE

Luke is warding off laser blasts with his lightsaber, surrounded by guards and fighting like a demon. Leia emerges onto the deck as Luke turns to face another guard.

LUKE: *(to Leia)* Get the gun! Point it at the deck!

Leia turns toward the barge cannon, climbs on the platform, and swivels the gun around.

LUKE: Point it at the deck!

A laser blast hits Luke's mechanical hand and he bends over in pain, but manages to swing his lightsaber upward and take out the last of the guards. He looks at the wounded hand, which reveals the mechanism. He flexes the hand; it still works.

Near the rail of the upper deck, Artoo and Threepio steady themselves as Threepio gets ready to jump. Artoo beeps wildly.

THREEPIO: Artoo, where are we going? I couldn't possibly jump.

Artoo butts the golden droid over the edge and steps off himself, tumbling toward the sand.

Luke runs along the empty deck toward Leia and the barge gun, which she has brought around to point down at the deck.

LUKE: Come on!

Luke has a hold on one of the rigging ropes from the mast. He gathers Leia in his other arm and kicks the trigger of the deck gun. The gun explodes into the deck as Luke and Leia swing out toward the skiff.

EXTERIOR: SKIFF

Han leans panting against the rail as Chewie helps Lando onto the deck. Luke and Leia land on the skiff with flair.

LUKE: Let's go! And don't forget the droids.

LANDO: We're on our way.

The sail barge is exploding in stages in the distance. Half of the huge craft is on fire.

EXTERIOR: SAND DUNE

Threepio's legs stick straight up from the dune where he landed. Next to it, Artoo's periscope is the only thing above sand. The skiff floats above them and two large electromagnets dangle down on a wire. With a loud clang, both droids are pulled from the sand.

EXTERIOR: DUNE SEA

The little skiff skips around the burning sail barge, which continues its chain of explosions. As the skiff sails off across the desert, the barge settles to the sand and disappears in one final conflagration.

EXTERIOR: SPACE ABOVE TATOOINE

The desolate yellow planet fills the screen. Luke's X-wing appears and peels off to the left. A moment later, the Falcon *appears as a dot and grows huge, to roar directly over camera.*

INTERIOR: X-WING COCKPIT

Luke is at the controls, with Artoo attached behind him outside the canopy. Luke speaks into his comlink to the others, in the Millennium Falcon.

LUKE: I'll meet you back at the fleet.

LEIA: *(over comlink)* Hurry. The Alliance should be assembled by now.

LUKE: I will.

HAN: *(over comlink)* Hey, Luke, thanks. Thanks for comin' after me. Now I owe you one.

A message from Artoo appears on the small monitor screen in front of Luke. He smiles at the monitor and speaks to Artoo, as he pulls a black glove on to cover his wounded mechanical hand.

LUKE: That's right, Artoo. We're going to the Dagobah system. I have a promise to keep . . . to an old friend.

EXTERIOR: SPACE—DEATH STAR AND ENDOR

A Super Star Destroyer and several ships of the Imperial Fleet rest in space above the half-completed Death Star and its green neighbor, Endor. Four squads of TIE fighters escort an Imperial shuttle toward the Death Star.

INTERIOR: DEATH STAR—CORRIDOR TO DOCKING BAY

Lord Vader strides down the hallway, accompanied by a very nervous Death Star commander.

INTERIOR: DOCKING BAY—DEATH STAR

Thousands of Imperial troops in tight formation fill the mammoth docking bay. Vader and the officer walk to the landing platform, where the shuttle is just coming to rest.
 The shuttle's ramp lowers and the Emperor's Royal Guards come out and create a lethal perimeter. The assembled troops

move to rigid attention with a momentous snap. Then, in the huge silence that follows, the Emperor appears. He is a rather small, shriveled old man. His bent frame slowly makes its way down the ramp with the aid of a gnarled cane. He wears a hooded cloak similar to the one Ben wears, except that it is black. The Emperor's face is shrouded and difficult to see, except for his piercing yellow eyes. Commander Jerjerrod and Darth Vader kneel to him. The Supreme Ruler of the galaxy beckons to the Dark Lord.

EMPEROR: *(to Vader)* Rise, my friend.

Vader rises and falls in next to the Emperor as he slowly makes his way along the rows of troops. Jerjerrod and the other commanders stay kneeling until the Supreme Ruler and Vader, followed by several Imperial dignitaries, pass by; only then do they join in the procession.

VADER: The Death Star will be completed on schedule.

EMPEROR: You have done well, Lord Vader. And now I sense you wish to continue your search for young Skywalker.

VADER: Yes, my master.

EMPEROR: Patience, my friend. In time he will seek *you* out. And when he does, you must bring him before me. He has grown strong. Only together can we turn him to the dark side of the Force.

VADER: As you wish.

EMPEROR: Everything is proceeding as I have foreseen.

He laughs to himself as they pass along the vast line of Imperial troops.

EXTERIOR: YODA'S HOUSE—DAGOBAH

Once again, Artoo finds himself waiting around in the damp environs of the swamp planet, and he's none too happy about it. He beeps disconsolately to himself and turns to look at Yoda's cottage. Warm yellow light escapes the oddly shaped windows to fight the gloom.

INTERIOR: YODA'S HOUSE

The tip of a walking stick taps hesitantly across the earthen floor of the cottage. Our view travels up the stick to the small green hand that clutches it, and then to the familiar face of Yoda, the Jedi Master. His manner is frail, and his voice, though cheerful, seems weaker.

YODA: Hmm. That face you make. Look I so old to young eyes?

Luke is sitting in a corner of the cramped space and, indeed, his look has been woeful. Caught, he tries to hide it.

LUKE: No . . . of course not.

YODA: *(tickled, chuckles)* I do, yes, I do! Sick have I become. Old and weak. *(points a crooked finger)* When nine hundred years old you reach, look as good you will not. Hmm?

Yoda chuckles at this, coughs, and hobbles over toward his bed.

YODA: Soon will I rest. Yes, forever sleep. Earned it, I have.

Yoda sits himself on his bed, with great effort.

LUKE: Master Yoda, you can't die.

YODA: Strong am I with the Force . . . but not that strong! Twilight is upon me and soon night must fall. That is the way of things . . . the way of the Force.

LUKE: But I need your help. I've come back to complete the training.

YODA: No more training do you require. Already know you that which you need.

Yoda sighs, and lies back on his bed.

LUKE: Then I am a Jedi?

YODA: *(shakes his head)* Ohhh. Not yet. One thing remains: Vader. You must confront Vader. Then, only then, a Jedi will you be. And confront him you will.

Luke is in agony. He is silent for a long moment, screwing up his courage. Finally he is able to ask.

LUKE: Master Yoda . . . is Darth Vader my father?

Yoda's eyes are full of weariness and compassion. An odd, sad smile creases his face. He turns painfully on his side, away from Luke.

YODA: Mmm . . . rest I need. Yes . . . rest.

Luke watches him, each moment an eternity.

LUKE: Yoda, I must know.

YODA: Your father he is.

Luke reacts as if cut.

YODA: Told you, did he?

LUKE: Yes.

A new look of concern crosses Yoda's face. He closes his eyes.

YODA: Unexpected this is, and unfortunate . . .

LUKE: Unfortunate that I know the truth?

Yoda opens his eyes again and studies the youth.

YODA: *(gathering all his strength)* No. Unfortunate that you rushed to face him . . . that incomplete was your training. Not ready for the burden were you.

LUKE: Well, I'm sorry.

YODA: Remember, a Jedi's strength flows from the Force. But beware. Anger, fear, aggression. The dark side are they. Once you start down the dark path, forever will it dominate your destiny.

He beckons the young Jedi closer to him.

YODA: Luke . . . Luke . . . Do not . . . Do not underestimate the powers of the Emperor, or suffer your father's fate, you will. Luke, when gone am I *(cough)*, the last of the Jedi will you be. Luke, the Force runs strong in your family. Pass on what you have learned. Luke . . . *(with great effort)* There is . . . another . . . Sky . . . Sky . . . walker.

He catches his breath. A shiver runs through the ancient green creature, and he dies. Luke stares at his dead master as he disappears in front of his eyes.

EXTERIOR: DAGOBAH SWAMP—X-WING

Luke wanders back to where his ship is sitting. Artoo beeps a greeting, but is ignored by his depressed master. Luke kneels down, begins to help Artoo with the ship, then stops and shakes his head dejectedly.

LUKE: I can't do it, Artoo. I can't go on alone.

BEN: *(offscreen)* Yoda will always be with you.

Luke looks up to see the shimmering image of Ben Kenobi.

LUKE: Obi-Wan! Why didn't you tell me?

The ghost of Ben Kenobi approaches him through the swamp.

LUKE: You told me Vader betrayed and murdered my father.

BEN: Your father was seduced by the dark side of the Force. He ceased to be Anakin Skywalker and became Darth Vader. When that happened, the good man who was your father was destroyed. So what I have told you was true . . . from a certain point of view.

LUKE: *(turning away, derisive)* A certain point of view!

BEN: Luke, you're going to find that many of the truths we cling to depend greatly on our own point of view.

Luke is unresponsive. Ben studies him in silence for a moment.

BEN: Anakin was a good friend.

Luke turns with interest at this. As Ben speaks, Luke settles on a stump, mesmerized. Artoo comes over to offer his comforting presence.

BEN: When I first knew him, your father was already a great pilot. But I was amazed how strongly the Force was with him. I took it upon myself to train him as a Jedi. I thought that I could instruct him just as well as Yoda. I was wrong.

Luke is entranced.

LUKE: There is still good in him.

BEN: He's more machine now than man. Twisted and evil.

LUKE: I can't do it, Ben.

BEN: You cannot escape your destiny. You must face Darth Vader again.

LUKE: I can't kill my own father.

BEN: Then the Emperor has already won. You were our only hope.

LUKE: Yoda spoke of another.

BEN: The other he spoke of is your twin sister.

LUKE: But I have no sister.

BEN: Hmm. To protect you both from the Emperor, you were hidden from your father when you were born. The Emperor knew, as I did, if Anakin were to have any offspring, they would be a threat to him. That is the reason why your sister remains safely anonymous.

LUKE: Leia! Leia's my sister.

BEN: Your insight serves you well. Bury your feelings deep down, Luke. They do you credit. But they could be made to serve the Emperor.

Luke looks into the distance, trying to comprehend all this.

EXTERIOR: SPACE—REBEL FLEET

The vast Rebel fleet stretches as far as the eye can see. Overhead a dozen small Corellian battleships fly in formation. Fighters and battlecruisers surround the largest of the Rebel Star Cruisers, the Headquarters Frigate.

INTERIOR: HEADQUARTERS FRIGATE—MAIN BRIEFING ROOM

Hundreds of Rebel commanders of all races and forms are assembling in the War Room. Wedge is among them. In the center of the room is a holographic model depicting the half-completed Imperial Death Star, the nearby Moon of Endor, and the protecting deflector shield.

Mon Mothma, the leader of the Alliance, enters the room. She is a stern but beautiful woman in her fifties. Conferring with her are several military leaders, including General Madine and

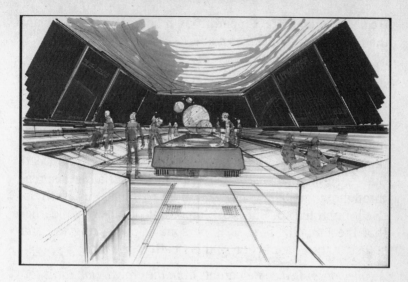

Admiral Ackbar (a salmon-colored Mon Calamari). Lando moves through the crowd until he finds Han and Chewie, standing next to Leia and the two droids.

Han peers at the new insignia on Lando's chest, and is amused.

HAN: Well, look at you, a general, huh?

LANDO: Oh, well, someone must have told them about my little maneuver at the Battle of Taanab.

HAN: *(sarcastic)* Well, don't look at me, pal. I just said you were a fair pilot. I didn't know they were lookin' for somebody to lead this crazy attack.

LANDO: *(smiling)* I'm surprised they didn't ask you to do it.

HAN: Well, who says they didn't. But I ain't crazy. You're the respectable one, remember?

Mon Mothma signals for attention, and the room falls silent.

MON MOTHMA: The Emperor has made a critical error and the time for our attack has come.

This causes a stir. Mon Mothma turns to a holographic model of the Death Star, the Endor moon, and the protecting deflector shield in the center of the room.

MON MOTHMA: The data brought to us by the Bothan spies pinpoints the exact location of the Emperor's new battle station. We also know that the weapon systems of this Death Star are not yet operational. With the Imperial fleet spread throughout the galaxy in a vain effort to engage us, it is relatively unprotected. But most important of all, we've learned that the Emperor himself is personally overseeing the final stages of the construction of this Death Star.

A volley of spirited chatter erupts from the crowd. Han turns to Leia as Chewie barks his amazement.

MON MOTHMA: *(continues)* Many Bothans died to bring us this information. Admiral Ackbar, please.

Admiral Ackbar steps forward and points to the Death Star's force field and the Moon of Endor.

ACKBAR: You can see here the Death Star orbiting the forest Moon of Endor. Although the weapon systems on this Death Star are not yet operational, the Death Star does have a strong defense mechanism. It is protected by an energy shield, which is generated from the nearby forest Moon of Endor. The shield must be deactivated if any attack is to be attempted. Once the shield is down, our cruisers will create a perimeter, while the fighters fly into the superstructure and attempt to knock out the main reactor.

There's a concerned murmur.

ACKBAR: *(continues)* General Calrissian has volunteered to lead the fighter attack.

Han turns to Lando with a look of respect.

HAN: Good luck.

Lando nods his thanks.

HAN: You're gonna need it.

ACKBAR: General Madine.

Madine moves center stage.

GENERAL MADINE: We have stolen a small Imperial shuttle. Disguised as a cargo ship, and using a secret Imperial code, a strike team will land on the moon and deactivate the shield generator.

The assembly begins to mumble among themselves.

THREEPIO: Sounds dangerous.

LEIA: *(to Han)* I wonder who they found to pull that off.

GENERAL MADINE: General Solo, is your strike team assembled?

Leia, startled, looks up at Han, surprise changing to admiration.

HAN: Uh, my team's ready. I don't have a command crew for the shuttle.

Chewbacca raises his hairy paw and volunteers. Han looks up at him.

HAN: Well, it's gonna be rough, pal. I didn't want to speak for you.

Chewie waves that off with a huge growl.

HAN: *(smiles)* That's one.

LEIA: Uh, General . . . count me in.

VOICE: *(offscreen)* I'm with you, too!

They turn in that direction and peer into the crowd as there are more cheers. The commanders part, and there at the back stands Luke. Han and Leia are surprised and delighted.

Leia moves to Luke and embraces him warmly. She senses a change in him and looks into his eyes questioningly.

LEIA: What is it?

LUKE: *(hesitant)* Ask me again sometime.

Han, Chewie, and Lando crowd around Luke as the assembly breaks up.

HAN: Luke.

LUKE: Hi, Han . . . Chewie.

Artoo beeps a singsong observation to a worried Threepio.

THREEPIO: "Exciting" is hardly the word I would use.

INTERIOR: HEADQUARTERS FRIGATE—MAIN DOCKING BAY

The Millennium Falcon *rests beyond the stolen Imperial shuttle, which looks anomalous among all the Rebel ships in the vast docking bay. Chewie barks a final farewell to Lando and leads Artoo and Threepio up the shuttle ramp, crowded now with the Rebel strike team loading weapons and supplies. Lando turns to face Han. Luke and Leia have said their good-byes and start up the ramp.*

HAN: Look: I want you to take her. I mean it. Take her. You need all the help you can get. She's the fastest ship in the fleet.

LANDO: All right, old buddy. You know, I know what she means to you. I'll take good care of her. She—she won't get a scratch. All right?

HAN: *(looks at him warmly)* Right. I got your promise now. Not a scratch.

LANDO: Look, would you get going, you pirate.

Han and Lando pause, then exchange salutes.

LANDO: Good luck.

HAN: You, too.

Han goes up the ramp. Lando watches him go and then slowly turns away.

INTERIOR: IMPERIAL SHUTTLE—COCKPIT

Luke is working on a back control panel as Han comes in and takes the pilot's seat. Chewie, in the seat next to him, is trying to figure out all the Imperial controls.

HAN: You got her warmed?

LUKE: Yeah, she's comin' up.

Chewie growls a complaint.

HAN: No, I don't think the Empire had Wookiees in mind when they designed her, Chewie.

Leia comes in from the hold and takes her seat near Luke.
 Chewie barks and hits some switches. Han's glance has stuck on something out the window: the Millennium Falcon. *Leia nudges him gently.*

LEIA: Hey, are you awake?

HAN: Yeah, I just got a funny feeling. Like I'm not gonna see her again.

Chewie, hearing this, stops his activity and looks longingly out at the Falcon, *too. Leia puts a hand on Han's shoulder.*

LEIA: *(softly)* Come on, General, let's move.

Han snaps back to life.

HAN: Right. Chewie, let's see what this piece of junk can do. Ready, everybody?

LUKE: All set.

THREEPIO: Here we go again.

HAN: All right, hang on.

EXTERIOR: SPACE—THE REBEL FLEET

The stolen Imperial shuttle leaves the main docking bay of the Headquarters Frigate, lowers its wings into flight position, and zooms off into space.

INTERIOR: EMPEROR'S THRONE ROOM

The converted control room is dimly lit, except for a pool of light at the far end. There the Emperor sits in an elaborate control chair before a large window which looks out across the half-completed Death Star to the giant green Moon of Endor.

Darth Vader, standing with other members of the Imperial council, cautiously approaches his master. The ruler's back is to Vader. After several tense moments, the Emperor's chair rotates around to face him.

VADER: What is thy bidding, my Master?

EMPEROR: Send the fleet to the far side of Endor. There it will stay until called for.

VADER: What of the reports of the Rebel fleet massing near Sullust?

EMPEROR: It is of no concern. Soon the Rebellion will be crushed and young Skywalker will be one of us! Your work here is finished, my friend. Go out to the command ship and await my orders.

VADER: Yes, my Master.

Vader bows, then turns and exits the throne room as the Emperor walks toward the waiting council members.

EXTERIOR: SPACE—DEATH STAR—MOON

There is a great deal of Imperial traffic in the area as construction proceeds on the Death Star. Transports, TIE fighters, and a few Star Destroyers move about. Now the huge Super Star Destroyer announces itself with a low roar and soon fills the frame.

INTERIOR: STOLEN IMPERIAL SHUTTLE—COCKPIT

Han looks back at Luke and Leia as Chewie flips several switches. Through the viewscreen, the Death Star and the huge Super Star Destroyer can be seen.

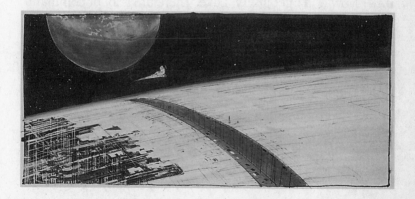

HAN: If they don't go for this, we're gonna have to get outta here pretty quick, Chewie.

Chewie growls his agreement.

CONTROLLER: *(over radio)* We have you on our screen now. Please identify.

HAN: Shuttle *Tydirium* requesting deactivation of the deflector shield.

CONTROLLER: *(over radio)* Shuttle *Tydirium*, transmit the clearance code for shield passage.

HAN: Transmission commencing.

Leia and Chewbacca listen tensely as the sound of a high speed transmission begins.

LEIA: Now we find out if that code is worth the price we paid.

HAN: It'll work. It'll work.

Chewie whines nervously. Luke stares at the huge Super Star Destroyer that looms ever larger before them.

LUKE: Vader's on that ship.

HAN: Now don't get jittery, Luke. There are a lot of command ships. Keep your distance though, Chewie, but don't *look* like you're trying to keep your distance.

Chewie barks a question.

HAN: I don't know. Fly casual.

LUKE: I'm endangering the mission. I shouldn't have come.

HAN: It's your imagination, kid. Come on. Let's keep a little optimism here.

Chewie barks his worries as the Super Star Destroyer grows larger out the window.

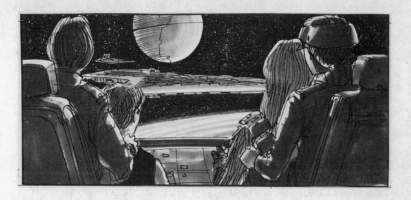

INTERIOR: VADER'S STAR DESTROYER—BRIDGE

Lord Vader stands, back to us, staring out a window at the Death Star. Now, some vibration felt only by him causes him to turn. After a moment of stillness, he walks down the row of controllers to where Admiral Piett is leaning over the tracking screen of the controller we've seen earlier. Piett straightens at Vader's approach.

VADER: Where is that shuttle going?

PIETT: *(into comlink)* Shuttle *Tydirium*, what is your cargo and destination?

PILOT VOICE (HAN): *(filtered)* Parts and technical crew for the forest moon.

The Bridge Commander looks to Vader for a reaction.

VADER: Do they have a code clearance?

PIETT: It's an older code, sir, but it checks out. I was about to clear them.

Vader looks upward, as he senses Luke's presence.

PIETT: Shall I hold them?

VADER: No. Leave them to me. I will deal with them myself.

PIETT: *(surprised)* As you wish, my lord. *(to controller)* Carry on.

Piett nods at the controller, who switches on his comlink.

INTERIOR: STOLEN IMPERIAL SHUTTLE—COCKPIT

The groups waits tensely.

HAN: They're not goin' for it, Chewie.

CONTROLLER: *(filtered)* Shuttle *Tydirium*, deactivation of the shield will commence immediately. Follow your present course.

Everyone breathes a sigh of relief. Everyone but Luke, who looks worried. Chewie barks.

HAN: Okay! I told you it was gonna work. No problem.

EXTERIOR: SPACE—STOLEN IMPERIAL SHUTTLE—ENDOR

The stolen Imperial shuttle moves off toward the green Sanctuary Moon.

EXTERIOR: FOREST LANDING SITE—ENDOR

The stolen Imperial shuttle sits in a clearing of the moon's dark, primeval forest, dwarfed by the ancient, towering trees.

On an adjacent hill, the helmeted Rebel contingent makes its way up a steep trail. Leia and Han are slightly ahead of Chewie and Luke. The troops of the strike-team squad follow, with Artoo and Threepio bringing up the rear. Artoo beeps.

Up ahead, Chewie and Leia reach a crest in the hill and drop suddenly to the ground, signaling the rest of the group to stop. Han and Luke crawl up to take a look.

THREEPIO: Oh. I told you it was dangerous here.

THEIR P.O.V.: *Not far below them, two Imperial scouts are wandering through bushes in the valley below. Their two rocket bikes are parked nearby.*

LEIA: Shall we try and go around?

HAN: It'll take time. This whole party'll be for nothing if they see us.

Leia motions for the squad to stay put, then she, Han, Luke, and Chewie start quietly down.

EXTERIOR: FOREST CLEARING—CAMPSITE

The four friends make their way to the edge of the clearing not far from the two Imperial scouts.

HAN: Chewie and I will take care of this. You stay here.

LUKE: Quietly, there might be more of them out there.

HAN: *(grins)* Hey . . . it's me.

Han and Chewie turn and start through the bushes toward the scouts. Luke and Leia exchange smiles.
 Han sneaks up behind one of the scouts, steps on a twig and the scout whirls, knocking Han into a tree. The scout shouts for his companion.

SCOUT #1: Go for help! Go!

The second scout jumps on his speeder bike and takes off, but Chewie gets off a shot on his crossbow laser weapon, causing the scout to crash into a tree. Han and Scout #1 are in a rousing fistfight.

LUKE: *(sarcastic)* Great. Come on.

Luke starts for the scuffle, followed by Leia with her laser pistol drawn. As they run through the bushes, Leia stops and points to where two more scouts are sitting on their speeder bikes, with an unoccupied bike parked nearby.

LEIA: Over there! Two more of them!

LUKE: I see them. Wait, Leia!

But Leia doesn't hear him and races for the remaining speeder bike. She starts it up and takes off as Luke jumps on the bike behind her.

LUKE: *(pointing to the controls)* Quick! Jam their comlink. Center switch!

Luke and Leia speed into the dense foliage in hot pursuit, barely avoiding two huge trees.

HAN: Hey, wait! Ahhh!

He flips the remaining scout to the ground.

EXTERIOR: FOREST—THE BIKE CHASE

The two fleeing Imperial scouts have a good lead as Luke and Leia pursue through the giant trees at 200 miles an hour, the fire from their bike's laser cannon hitting harmlessly near the moving targets.

LUKE: Move closer!

Leia guns it, closing the gap, as the two scouts recklessly veer through a narrow gap in the trees. One of the bikes scrapes a tree, slowing the scout.

LUKE: Get alongside that one!

Leia pulls her speeder bike up so close to the scout's bike that their steering vanes scrape noisily. Luke leaps from his bike to

the back of the scout's, grabs the Imperial warrior around the neck, and flips him off the bike, into a thick tree trunk. Luke gains control of the bike and follows Leia, who has pulled ahead. They tear off after the remaining scout.

LUKE: Get him!

The speeder chase passes two more Imperial scouts. These two swing into pursuit, chasing Luke and Leia, firing away with their laser cannon. The two Rebels look behind them just as Luke's bike takes a glancing hit.

LUKE: (indicating the one ahead) Keep on that one! I'll take these two!

With Leia shooting ahead, Luke suddenly slams his steering vanes into the braking mode. Luke's bike is a blur to the two pursuing scouts as they zip by him on either side. Luke slams his bike into forward and starts firing away, having switched places with his pursuers in a matter of seconds. Luke's aim is good and one scout's bike is blasted out of control. It explodes against a tree trunk.

The scout's cohort takes one glance back at the flash and shifts into turbo drive, going even faster. Luke keeps on his tail.

Far ahead, Leia and the first scout are doing a high-speed slalom through the death-dealing trunks. Now Leia aims her bike skyward and rises out of sight.

The scout turns in confusion, unable to see his pursuer. Suddenly, Leia dives down upon him from above, cannon blasting. The scout's bike takes a glancing hit.

Leia moves in alongside him. The scout eyes her beside him, reaches down, and pulls out a handgun. Before Leia can react, the scout has blasted her bike, sending it out of control. Leia dives off as her bike explodes against a tree. The happy scout looks back at the explosion. But when he turns forward again, he is on a collision course with a giant fallen tree. He hits his brakes to no avail and disappears in a conflagration.

Another part of the forest: Luke and the last remaining scout continue their weaving chase through the trees. Now Luke moves up close. The scout responds by slamming his bike into Luke's. A fallen tree forms a bridge across their path. The scout zips under. Luke goes over the top and crashes his bike down on the scout's. Both riders look ahead—a wide trunk looms directly in Luke's path, but the scout's bike beside him makes it almost impossible for him to avoid it. Luke banks with all his might, leaning almost horizontal over the scout's bike, and is able to make it by, just clipping the tree. When he straightens, he and the scout discover that their two bikes have locked front vanes and are moving as one.

Another big tree looms in Luke's path. He reacts instinctively and dives off the bike. The two bikes come apart a second before Luke's explodes against the tree. The scout sweeps out and circles back to find Luke.

Luke rises from the undergrowth as the scout bears down on him and opens fire with his laser cannon. Luke ignites his laser sword and begins deflecting the bolts. The scout's bike keeps coming and it appears that in a second it will cut Luke in half. At the last instant, Luke steps aside and chops off the bike's control vanes with one mighty slash. The scout's bike begins to

shudder, then, pitching and rolling, it rises up to slam directly into a tree in a giant ball of fire.

EXTERIOR: SCOUT CAMPSITE—FOREST

Han, Chewie, and the droids, along with the rest of the squad, wait anxiously in the clearing. Artoo's radar screen sticks out of his domed head and revolves, scanning the forest. He beeps.

THREEPIO: Oh, General Solo, somebody's coming. Oh!

Han, Chewie, and the rest of the squad raise their weapons.
 Luke steps out of the foliage to find the weapons trained on him. He's too tired to care. He plops himself down on a boulder and looks around.

HAN: Luke! Where's Leia?

LUKE: *(concerned)* What? She didn't come back?

HAN: I thought she was with you.

LUKE: We got separated.

Luke and Han exchange a silent, grim look. Luke gets up wearily.

LUKE: Hey, we better go look for her.

Han nods, and signals to a Rebel officer.

HAN: Take the squad ahead. We'll meet at the shield generator at 0300.

LUKE: Come on, Artoo. We'll need your scanners.

Luke, Chewie, Han, and the droids move off in one direction as the squad proceeds in another.

THREEPIO: Don't worry, Master Luke. We know what to do.

They move off into the woods.

THREEPIO: *(to Artoo)* And you said it was pretty here. Ugh!

EXTERIOR: FOREST CLEARING—LEIA'S CRASH SITE

A strange little furry face with huge black eyes comes slowly into view. The creature is an Ewok by the name of Wicket. He seems somewhat puzzled, and prods Leia with a spear. The princess groans; this frightens the stubby ball of fuzz and he prods her again. Leia sits up and stares at the three-foot-high Ewok. She tries to figure out where she is and what has happened. Her clothes are torn; she's bruised and disheveled.

The Ewok jumps up and grabs a four-foot-long spear, which he holds in a defensive position. Leia watches him as he circles warily and begins poking her with the sharp point of the spear.

LEIA: Cut it out!

She stands up, and the Ewok quickly backs away.

LEIA: I'm not gonna hurt you.

Leia looks around at the dense forest, and at the charred remains of her speeder bike, then sits down, with a sigh, on a fallen log.

LEIA: Well, looks like I'm stuck here. Trouble is, I don't know where here is.

She puts her head in her hands to rub away some of the soreness from her fall. She looks over at the watchful little Ewok and pats the log beside her.

LEIA: Well, maybe you can help me. Come on, sit down.

Wicket holds his spear up warily and growls at her like a puppy. Leia pats the log again.

LEIA: I promise I won't hurt you. Now come here.

More growls and squeaks from the little bear creature.

LEIA: All right. You want something to eat?

*She takes a scrap of food out of her pocket and offers it to him.
Wicket takes a step backward, then cocks his head and moves
cautiously toward Leia, chattering in his squeaky Ewok
language.*

LEIA: That's right. Come on. Hmmm?

*Sniffing the food curiously, the Ewok comes toward Leia and sits
on the log beside her. She takes off her helmet, and the little
creature jumps back, startled again. He runs along the log,
pointing his spear at her and chattering a blue streak. Leia holds
out the helmet to him.*

LEIA: Look, it's a hat. It's not gonna hurt you. Look. You're a
jittery little thing, aren't you?

*Reassured, Wicket lowers his spear and climbs back on the log,
coming to investigate the helmet. Suddenly his ears perk up and
he begins to sniff the air. He looks around warily, whispering
some Ewokese warning to Leia.*

LEIA: What is it?

*Suddenly a laser bolt comes out of the foliage and explodes on
the log next to Leia. Leia and Wicket both roll backwards off the
log, hiding behind it. Leia holds her own laser gun ready, while
Wicket disappears underneath the log. Another shot, and still no
sign of anyone in the forest. Then Leia senses something and
turns to find a large Imperial scout standing over her with his
weapon pointed at her head. He reaches out his hand for her
weapon.*

SCOUT #1: Freeze! Come on, get up!

*She hands the weapon over, as a second scout emerges from
the foliage in front of the log.*

SCOUT #1: Go get your ride and take her back to base.

SCOUT #2: Yes, sir.

The second scout starts toward his bike, as Wicket, crouched under the log, extends his spear and hits the first scout on the leg. The scout jumps and lets out an exclamation, and looks down at Wicket, puzzled. Leia grabs a branch and knocks him out. She dives for his laser pistol, and the second scout, now on his bike, takes off. Leia fires away and hits the escaping bike, causing it to crash into the first scout's bike, which flies end over end and explodes. The forest is quiet once more. Wicket pokes his fuzzy head up from behind the log and regards Leia with new respect. He mumbles his awe. Leia hurries over, looking around all the time, and motions the chubby little creature into the dense foliage.

LEIA: Come on, let's get outta here.

As they move into the foliage, Wicket takes the lead. He shrieks and tugs at Leia to follow him.

INTERIOR: EMPEROR'S TOWER—THRONE ROOM

Two red Imperial Guards stand watch at the elevator as the door opens to reveal Vader. Vader enters the eerie, foreboding throne room. It appears to be empty. His footsteps echo as he approaches the throne. He waits, absolutely still. The Emperor sits with his back to the Dark Lord.

EMPEROR: I told you to remain on the command ship.

VADER: A small Rebel force has penetrated the shield and landed on Endor.

EMPEROR: *(no surprise)* Yes, I know.

VADER: *(after a beat)* My son is with them.

EMPEROR: *(very cool)* Are you sure?

VADER: I have felt him, my Master.

EMPEROR: Strange, that I have not. I wonder if your feelings on this matter are clear, Lord Vader.

Vader knows what is being asked.

VADER: They are clear, my Master.

EMPEROR: Then you must go to the Sanctuary Moon and wait for him.

VADER: *(skeptical)* He will come to me?

EMPEROR: I have foreseen it. His compassion for you will be his undoing. He will come to you and then you will bring him before me.

VADER: *(bows)* As you wish.

The Dark Lord strides out of the throne room.

EXTERIOR: FOREST CLEARING—LEIA'S CRASH SITE

Han, Luke, Chewie, and the two droids are spread out as they move through the heavy foliage near the clearing where we last saw Leia. Luke finds Leia's helmet, picks it up with an expression of concern.

HAN: *(offscreen)* Luke! Luke!

Luke runs with the helmet to where Han has found the charred wreckage of a speeder bike in the grass.

THREEPIO: Oh, Master Luke.

LUKE: There's two more wrecked speeders back there. And I found this.

He tosses the helmet to Han.

THREEPIO: I'm afraid that Artoo's sensors can find no trace of Princess Leia.

HAN: *(gravely)* I hope she's all right.

Chewbacca growls, sniffing the air, then, with a bark, pushes off through the foliage.

HAN: What, Chewie? What? Chewie!

The others rush to keep up with the giant Wookiee. As he scoots along, Artoo whistles nervously.

EXTERIOR: FOREST—DENSE FOLIAGE

The group has reached a break in the undergrowth. Chewie walks up to a tall stake planted in the ground. There is a dead animal hanging from it.

HAN: Hey, I don't get it.

The rest of the group joins the Wookiee around the stake.

HAN: *(continues)* Nah, it's just a dead animal, Chewie.

Chewie can't resist. He reaches toward the meat.

LUKE: Chewie, wa-wait! Don't!

Too late. The Wookiee has already pulled the animal from the stake. Sprooing! *The group finds itself hanging upside down in an Ewok net, suspended high above the clearing. Artoo lets out a wild series of beeps and whistles, and Chewie howls his regret. Their bodies are a jumble in the net. Han removes a Wookiee paw from his mouth.*

HAN: Nice work. Great, Chewie! Great! Always thinking with your stomach.

LUKE: Will you take it easy? Let's just figure out a way to get out of this thing. *(trying to free an arm)* Han, can you reach my lightsaber?

HAN: Yeah, sure.

Artoo is at the bottommost point in the net. He extends his cutting appendage and begins slicing at the net. Han is trying to squeeze an arm past Threepio to get at Luke's lightsaber. The net continues to spin.

THREEPIO: Artoo, I'm not sure that's such a good idea. It's a very long dro-o-op!!

Artoo has cut through and the entire group tumbles out of the net, crashing to the ground. As they regain their senses and sit up, they realize they are surrounded by dozens of Ewoks, each brandishing a long spear.

HAN: Wha— . . . ? Hey! Point that thing someplace else.

Han pushes the spear wielded by Teebo out of his face and a second Ewok warrior comes up to argue with Teebo. The spear returns to Han's face. He grabs it angrily and starts to go for his laser pistol.

HAN: Hey!

LUKE: Han, don't. It'll be all right.

The Ewoks swarm through them and confiscate their weapons. Luke lets them take his lightsaber. Chewie growls at the furry critters.

LUKE: Chewie, give 'em your crossbow.

Artoo and Threepio are just untangling themselves. Threepio gets free of the net and sits up, rattled.

THREEPIO: Oh, my head. Oh, my goodness!

When the Ewoks see Threepio, they let out a gasp and chatter among themselves. Threepio speaks to them in their native tongue. The Ewok nearest him drops his spear and prostrates himself before the droid. In a moment, all the Ewoks have followed suit. Chewie lets out a puzzled bark. Han and Luke regard the bowed creatures in wonder. The Ewoks begin to chant at Threepio.

LUKE: Do you understand anything they're saying?

THREEPIO: Oh, yes, Master Luke! Remember that I am fluent in over six million forms of communication.

HAN: What are you telling them?

THREEPIO: Hello, I think . . . I could be mistaken. They're using a very primitive dialect. But I do believe they think I am some sort of god.

Chewbacca and Artoo think that's very funny. Han and Luke exchange "what next?" looks.

HAN: Well, why don't you use your divine influence and get us out of this?

THREEPIO: I beg your pardon, General Solo, but that just wouldn't be proper.

HAN: Proper?!

THREEPIO: It's against my programming to impersonate a deity.

Han moves toward Threepio threateningly.

HAN: Why, you . . .

Several Ewoks' spears are thrust in Han's face at the affront to their god. The Ewoks move in to protect their god and Han is surrounded by a menacing circle of spears, all aimed at him. He holds up his hands placatingly.

HAN: My mistake. He's an old friend of mine.

EXTERIOR: FOREST—SERIES OF SHOTS

A procession of Ewoks winds through the ever-darkening forest. Their prisoners—Han, Luke, Chewie, and Artoo—are tied to long poles and wrapped in vines, cocoonlike.
 Each pole is carried on the shoulders of several Ewoks. Behind the captives, Threepio is carried on a litter, like a king, by the remaining creatures.

EXTERIOR: FOREST WALKWAY—MOON FOREST

The procession moves along a shaky, narrow, wooden walkway, high in the giant trees. It stops at the end of the walkway, which drops off into nothingness. On the other side of the abyss is a village of mud huts and rickety walkways, attached to the giant trees. The lead Ewok takes hold of a long vine and swings across to the village square; the other Ewoks follow suit.

EXTERIOR: EWOK VILLAGE SQUARE

The procession winds its way into the village square. Mother Ewoks gather their babies up and scurry into their huts at the sight of the newcomers. The group stops before the largest hut.
 Han, Luke, Chewie, and Artoo are still bound to their poles. Han is placed on a spit above what looks like a barbecue pit and the others are leaned against a tree nearby. Threepio's litter/throne is gently placed near the pit. He watches with rapt fascination. Han, Luke, and Chewie are less than fascinated.

HAN: I have a really bad feeling about this.

Chewie growls his concern.
 Suddenly all activity stops as Logray, the tribal Medicine Man,

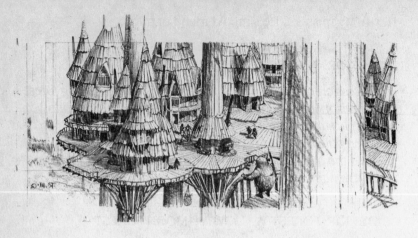

comes out of the big hut. He examines the captives carefully, goes to join Threepio, whose throne has been placed on an elevated platform. A larger, gray-haired Ewok, Chief Chirpa, is examining Luke's lightsaber with great curiosity.

Logray speaks to Threepio and the assemblage of fuzzy Ewoks, pointing to the prisoners tied to the stakes. The Ewoks begin filling the pit under Han with firewood.

HAN: What did he say?

THREEPIO: I'm rather embarrassed, General Solo, but it appears you are to be the main course at a banquet in my honor.

The drums start beating, and all the furry heads turn to the large hut. Leia emerges, wearing an animal-skin dress. She sees what's happening at the same moment the prisoners see her.

HAN AND LUKE: Leia!

As she moves toward them, the Ewoks block her way with raised spears.

LEIA: Oh!

THREEPIO: Your Royal Highness.

Artoo and Chewie chime in with their welcome. Leia looks around at the assembled Ewoks and sighs.

LEIA: But these are my friends. Threepio, tell them they must be set free.

Threepio talks to Chirpa and Logray, who listen and shake their heads negatively. The Medicine Man gestures toward the prisoners and barks some orders. Several Ewoks jump up and pile more wood on the barbecue with vigor. Leia trades frantic looks with Luke and Han.

HAN: Somehow, I got the feeling that didn't help us very much.

LUKE: Threepio, tell them if they don't do as you wish, you'll become angry and use your magic.

THREEPIO: But Master Luke, what magic? I couldn't possibly—

LUKE: Just tell them.

Threepio speaks to the Ewoks. The Ewoks are disturbed. Logray steps forward and challenges Threepio. Luke closes his eyes and begins to concentrate.

THREEPIO: You see, Master Luke, they didn't believe me. Just . . .

Now the litter/throne with Threepio sitting upon it, rises from the ground. At first Threepio doesn't notice and keeps talking.

THREEPIO: . . . as I said they wouldn't. Wha-wha-what's happening! Oh! Oh, dear! Oh!

The Ewoks fall back in terror from the floating throne. Now Threepio begins to spin as though he were on a revolving stool, with Threepio calling out in total panic at his situation.

THREEPIO: Put me down! He-e-elp! Master Luke! Artoo! Somebody, somebody, help! Master Luke, Artoo! Artoo, quickly! Do something, somebody! Oh! Ohhh!

Chief Chirpa yells orders to the cowering Ewoks. They rush up and release the bound prisoners. Luke and Han enfold Leia in a group embrace. Luke notices the spinning Threepio, with Artoo beeping up at him, and slowly lowers the golden droid and the throne to the ground. Logray orders the little droid cut down. Artoo crashes to the ground. When the Ewoks set him upright, the little droid is fighting mad. Artoo beeps a blue streak at the nearest Ewok, and begins pursuing him, finally getting close enough to zap him with an electric charge. The Ewok jumps two feet in the air and runs away, screaming. A small group of Ewoks surround the giant Wookiee, scratching their heads and marveling at his height.

THREEPIO: Oh, oh, oh, oh! Thank goodness.

LUKE: Thanks, Threepio.

THREEPIO: (*still shaken*) I . . . I never knew I had it in me.

INTERIOR: CHIEF'S HUT—COUNCIL OF ELDERS

A glowing fire dances in the center of the spartan, low-ceilinged room, creating a kaleidoscope of shadows on the walls. Along one side, a group of ten Ewok elders flanks Chief Chirpa, who sits on his throne. The Rebels sit along the walls of the hut, with Threepio between the two groups and Wicket and Teebo off to one side.

Threepio is in the midst of a long, animated speech in the Ewoks' squeaky native tongue. The Ewoks listen carefully and occasionally murmur comments to each other. Threepio points several times at the Rebel group and pantomimes a short history of the Galactic Civil War, mimicking the explosion and rocket sounds, imitating Imperial walkers. Throughout the long

account, certain familiar names are distinguishable in English: Princess Leia, Artoo, Darth Vader, Death Star, Jedi, Obi-Wan Kenobi. Artoo begins beeping excitedly at Threepio.

THREEPIO: Yes, Artoo. I was just coming to that.

Threepio continues with Millennium Falcon, *Cloud City, Vader, Han Solo, carbonite, Sarlacc, bringing the history up to the present time.*

At the end of it, the Chief, Logray, and the elders confer, then nod in agreement. The Chief stands and makes a pronouncement.

The drums begin to sound, and all the Ewoks stand with a great cheer and screeches.

HAN: What's going on?

LEIA: I don't know.

Luke has been sharing the joy with smiling visage, but now something passes like a dark cloud through his consciousness. The others do not notice.

THREEPIO: Wonderful! We are now a part of the tribe.

Several of the little teddy bears run up and hug the Rebels.

HAN: Just what I always wanted.

Chewbacca is being enthusiastically embraced by an Ewok, while Wicket clings to Han's leg.

HAN: *(chuckles)* Well, short help is better than no help at all, Chewie. *(to Wicket)* Thank you. Okay.

THREEPIO: He says the scouts are going to show us the quickest way to the shield generator.

Chewie barks. Luke has drifted to the back of the hut. Now he wanders outside into the moonlight. Leia notices and follows.

HAN: Good. How far is it? Ask him. We need some fresh supplies, too. And try and get our weapons back.

Han pulls Threepio back as he keeps trying to translate.

HAN: *(continues)* And hurry up, will ya? I haven't got all day.

EXTERIOR: EWOK VILLAGE

The walkway is deserted now. The windows of the little huts glow and flicker from the fires inside. The sounds of the forest fill the soft night air. Luke has wandered away from the chief's hut and stands staring up at the Death Star. Leia finds him like that.

LEIA: Luke, what's wrong?

Luke turns and looks at her a long moment.

LUKE: Leia . . . do you remember your mother? Your real mother?

LEIA: Just a little bit. She died when I was very young.

LUKE: What do you remember?

LEIA: Just . . . images, really. Feelings.

LUKE: Tell me.

LEIA: *(a little surprised at his insistence)* She was very beautiful. Kind, but . . . sad *(looks up)* Why are you asking me this?

He looks away.

LUKE: I have no memory of my mother. I never knew her.

LEIA: Luke, tell me. What's troubling you?

LUKE: Vader is here . . . now, on this moon.

LEIA: *(alarmed)* How do you know?

LUKE: I felt his presence. He's come for me. He can feel when

74

I'm near. That's why I have to go. (*facing her*) As long as I stay, I'm endangering the group and our mission here. (*beat*) I have to face him.

Leia is distraught, confused.

LEIA: Why?

Luke moves close and his manner is gentle. And very calm.

LUKE: He's my father.

LEIA: Your father?!

LUKE: There's more. It won't be easy for you to hear it, but you must. If I don't make it back, you're the only hope for the Alliance.

Leia is very disturbed by this. She moves away, as if to deny it.

LEIA: Luke, don't talk that way. You have a power I-I don't understand and could never have.

LUKE: You're wrong, Leia. You have that power, too. In time you'll learn to use it as I have. The Force is strong in my family. My father has it. . . . I have it . . . and . . . my sister has it.

Leia stares into his eyes. What she sees there frightens her. But she doesn't draw away. She begins to understand.

LUKE: Yes. It's you, Leia.

LEIA: I know. Somehow . . . I've always known.

LUKE: Then you know why I have to face him.

LEIA: No! Luke, run away, far away. If he can feel your presence, than leave this place. I wish I could go with you.

LUKE: No, you don't. You've always been strong.

LEIA: But, why must you confront him?

LUKE: Because . . . there is good in him. I've felt it. He won't turn me over to the Emperor. I can save him. I can turn him back to the good side. I have to try.

They hold each other close and look at each other, brother and sister.

Leia holds back her tears as Luke slowly lets her go and moves away. He disappears onto the walkway that leads out of the village. Leia, bathed in moonlight, watches him go as Han comes out of the chief's hut and comes over to her.

Leia is crying, her body trembling. He realizes only now that she is crying.

HAN: Hey, what's goin' on?

Leia attempts to stifle her sobs and wipes her eyes.

LEIA: Nothing. I—just want to be alone for a little while.

HAN: *(angry)* Nothing? Come on, tell me. What's goin' on?

She looks up at him, struggling to control herself.

LEIA: I . . . I can't tell you.

HAN: *(loses his temper)* Did you tell Luke? Is that who you could tell?

LEIA: I . . .

HAN: Ahhh . . .

He starts to walk away, exasperated, then stops and walks back to her.

HAN: I'm sorry.

LEIA: Hold me.

Han gathers her tightly in his protective embrace.

EXTERIOR: FOREST—IMPERIAL LANDING PLATFORM

An Imperial shuttle floats down from the Death Star and lands gracefully on the huge platform.

Now, an Imperial walker approaches the platform from the darkness of the forest. The whole outpost—platform, walkers, military—looks particularly offensive in the midst of this verdant beauty.

EXTERIOR: IMPERIAL LANDING PLATFORM—LOWER DECK

Darth Vader walks down the ramp of the shuttle onto the platform, into an elevator, and appears on a ramp on a lower level. He walks toward another ramp exit and is met by two troopers and a commander with Luke, in binders, at their center. The young Jedi gazes at Vader with complete calm.

COMMANDER: This is a Rebel that surrendered to us. Although he denies it, I believe there may be more of them, and I request permission to conduct a further search of the area.

The commander extends his hand, revealing Luke's lightsaber.

COMMANDER: He was armed only with this.

Vader looks at Luke, turns away and faces the commander, taking the lightsaber from the commander's hand.

VADER: Good work, Commander. Leave us. Conduct your search and bring his companions to me.

COMMANDER: Yes, my lord.

The officer and troops withdraw. Vader and Luke are left standing alone in the oddly tranquil beauty of the place. The sounds of the forest filter in upon them.

VADER: The Emperor has been expecting you.

LUKE: I know, Father.

VADER: So, you have accepted the truth.

LUKE: I've accepted the truth that you were once Anakin Skywalker, my father.

VADER: *(turning to face him)* That name no longer has any meaning for me.

LUKE: It is the name of your true self. You've only forgotten. I know there is good in you. The Emperor hasn't driven it from you fully. That was why you couldn't destroy me. That's why you won't bring me to your Emperor now.

Vader looks down from Luke to the lightsaber in his own black-gloved hand. He seems to ponder Luke's words.

VADER: *(indicating the lightsaber)* I see you have constructed a new lightsaber.

Vader ignites the lightsaber and holds it to examine its humming, brilliant blade.

VADER: Your skills are complete. Indeed, you are powerful, as the Emperor has foreseen.

They stand for a moment, then Vader extinguishes the lightsaber.

LUKE: Come with me.

VADER: Obi-Wan once thought as you do.

Luke steps close to Vader, then stops. Vader is still.

VADER: You don't know the power of the dark side. I must obey my master.

LUKE: I will not turn . . . and you'll be forced to kill me.

VADER: If that is your destiny.

LUKE: Search your feelings, Father. You can't do this. I feel the conflict within you. Let go of your hate.

VADER: It is too late for me, son. The Emperor will show you the true nature of the Force. *He* is your master now.

Vader signals to some distant stormtroopers. He and Luke stand staring at one another for a long moment.

LUKE: Then my father is truly dead.

EXTERIOR: ENDOR—RIDGE OVERLOOKING SHIELD GENERATOR

Han, Leia, Chewbacca, the droids, Wicket, and another Ewok scout, Paploo, hide on a ridge overlooking the massive Imperial shield generator. At the base of the generator is an Imperial landing platform. Leia studies the installation.

LEIA: The main entrance to the control bunker's on the far side of that landing platform. This isn't gonna be easy.

HAN: Hey, don't worry. Chewie and me got into a lot of places more heavily guarded than this.

Wicket and Paploo are chattering away in Ewok language. They speak to Threepio.

LEIA: What's he saying?

THREEPIO: He says there's a secret entrance on the other side of the ridge.

EXTERIOR: SPACE—REBEL FLEET

The vast fleet hangs in space near a blue planet. A giant Rebel Star Cruiser is up at the front, but now the Millennium Falcon *roars up to a spot ahead of it, tiny in comparison.*

INTERIOR: MILLENNIUM FALCON—COCKPIT

Lando is in the pilot seat. His alien copilot, Nien Nunb, takes some getting used to in the familiar environs of the Falcon's *cockpit. Lando speaks into his comlink.*

LANDO: Admiral, we're in position. All fighters accounted for.

ACKBAR: *(voice-over)* Proceed with the countdown. All groups assume attack coordinates.

Lando turns to his weird copilot.

LANDO: Don't worry, my friends are down there. They'll have that shield down on time . . . *(to himself)* or this'll be the shortest offensive of all time.

The copilot flips some switches and grunts an alien comment.

ACKBAR: *(voice-over)* All craft, prepare to jump into hyperspace on my mark.

LANDO: All right. Stand by.

He pulls a lever, and the stars outside begin to streak.

EXTERIOR: SPACE—REBEL FLEET

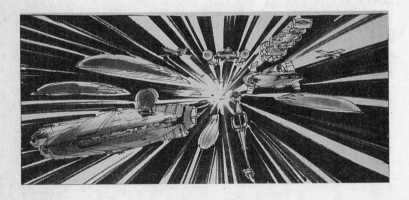

We are treated to an awesome sight: first the Millennium Falcon, *then Ackbar's Star Cruiser, then, in large segments, the huge fleet roars into hyperspace. And disappears.*

EXTERIOR: ENDOR—RIDGE OVERLOOKING CONTROL BUNKER

Han, Leia, Chewie, the droids, and their two Ewok guides, Wicket and Paploo, have reunited with the Rebel strike squad. The entire group is spread through the thick undergrowth. Below them is the bunker that leads into the generator. Four Imperial scouts, their speeder bikes parked nearby, keep watch over the bunker entrance. Chewie growls an observation, and Paploo chatters away to Han in Ewok language.

HAN: Back door, huh? Good idea.

Wicket and Paploo continue their Ewok conversation.

HAN: *(continues)* It's only a few guards. This shouldn't be too much trouble.

LEIA: Well, it only takes one to sound the alarm.

HAN: *(with self-confident grin)* Then we'll do it real quiet-like.

Threepio explains what is going on to Wicket and Paploo. The Ewoks chatter a moment between themselves. Then Paploo jumps up and scampers into the underbrush.

Threepio asks Wicket where Paploo went and is given a short reply.

THREEPIO: Oh! Oh, my. Uh, Princess Leia!

LEIA: Quiet.

THREEPIO: I'm afraid our furry companion has gone and done something rather rash.

LEIA: Oh, no.

EXTERIOR: THE BUNKER ENTRANCE

Paploo has slipped out of the undergrowth near where the Imperial scouts are lounging. He silently swings his furry ball of a body onto one of the scouts' speeder bikes and begins flipping switches at random. Suddenly, the bike's engine fires up with a tremendous roar. Paploo grins and continues flipping switches. The scouts leap up in surprise.

EXTERIOR: RIDGE

Han, Leia, and company watch in distress. Chewie barks.

HAN: *(sighs)* There goes our surprise attack.

EXTERIOR: BUNKER

The Imperial scouts race toward Paploo just as his speeder bike zooms into motion. Paploo hangs on by his paws and shoots away into the forest.

SCOUT: Look! Over there! Stop him!

Three of the Imperial scouts jump on their rocket bikes and speed away in pursuit. The fourth watches them go from his post at the door.

EXTERIOR: RIDGE

Han, Leia, and Chewie exchange delighted looks.

HAN: Not bad for a little furball. There's only one left. You stay here. We'll take care of this.

Han and the Wookiee nod at each other and slip down toward the bunker. Threepio moves to stand next to Wicket and Artoo.

THREEPIO: I have decided that we shall stay here.

EXTERIOR: FOREST

Paploo sails through the trees, more lucky than in control. It's scary, but he loves it. When the Imperial scouts pull within sight behind him and begin firing laser bolts, he decides he's had enough. As he rounds a tree, out of their sight, Paploo grabs a vine and swings up into the trees. A moment later, the scouts tear under him in pursuit of the still-flying, unoccupied bike.

EXTERIOR: BUNKER

Han sneaks up behind the remaining Imperial scout, taps him on the shoulder and lets the scout chase him behind the bunker into the arms of the waiting Rebel strike team. Han returns to the front, and taps out a pattern on the bunker door's control panel. Everyone stands out of sight, police-style, as the door opens. Han and Leia peek inside. No sign of life. The group enters the bunker silently, leaving one lookout behind.

INTERIOR: DEATH STAR—EMPEROR'S THRONE ROOM

The elevator opens. Vader and Luke enter the room alone. They walk across the dark space to stand before the throne, father

and son, side by side beneath the gaze of the Emperor. Vader bows to his master.

EMPEROR: Welcome, young Skywalker. I have been expecting you.

Luke peers at the hooded figure defiantly. The Emperor smiles, then looks down at Luke's binders.

EMPEROR: You no longer need those.

The Emperor motions ever so slightly with his finger and Luke's binders fall away, clattering noisily to the floor. Luke looks down at his own hands, free now to reach out and grab the Emperor's neck. He does nothing.

EMPEROR: Guards, leave us.

The red-cloaked guards turn and disappear behind the elevator.

EMPEROR: *(to Luke)* I'm looking forward to completing your training. In time you will call *me* Master.

LUKE: You're gravely mistaken. You won't convert me as you did my father.

The Emperor gets down from his throne and walks up very close to Luke. The Emperor looks into his eyes and, for the first time, Luke can perceive the evil visage within the hood.

EMPEROR: Oh, no, my young Jedi. You will find that it is *you* who are mistaken . . . about a great many things.

VADER: His lightsaber.

Vader extends a gloved hand toward the Emperor, revealing Luke's lightsaber. The Emperor takes it.

EMPEROR: Ah, yes, a Jedi's weapon. Much like your father's. By now you must know your father can never be turned from the dark side. So will it be with you.

LUKE: You're wrong. Soon I'll be dead . . . and you with me.

The Emperor laughs.

EMPEROR: Perhaps you refer to the imminent attack of your Rebel fleet.

Luke looks up sharply.

EMPEROR: Yes . . . I assure you we are quite safe from your friends here.

Vader looks at Luke.

LUKE: Your overconfidence is your weakness.

EMPEROR: Your faith in your friends is yours.

VADER: It is pointless to resist, my son.

The Emperor turns to face Luke.

EMPEROR: *(angry)* Everything that has transpired has done so according to *my* design. *(indicates Endor)* Your friends up there on the Sanctuary Moon . . .

Luke reacts. The Emperor notes it.

EMPEROR: *(continues)* . . . are walking into a trap. As is your Rebel fleet! It was I who allowed the Alliance to know the location of the shield generator. It is quite safe from your pitiful little band. An entire legion of my best troops awaits them.

Luke's look darts from the Emperor to Vader and, finally, to the sword in the Emperor's hand.

EMPEROR: Oh . . . I'm afraid the deflector shield will be quite operational when your friends arrive.

INTERIOR: BUNKER—MAIN CONTROL ROOM

Han, Leia, Chewie, and the Rebel strike team storm through a door and enter the main control room, taking all of the personnel prisoner.

HAN: All right! Up! Move! Come on! Quickly! Quickly, Chewie.

The Rebel troops herd the generator controllers away from their panels. Leia glances at one of the screens on the control panel.

LEIA: Han! Hurry! The fleet will be here any moment.

HAN: Charges! Come on, come on!

Outside, Threepio watches nervously in the bushes as several more controllers and stormtroopers run into the bunker, leaving guards at the door.

THREEPIO: *(to Wicket)* Oh, my! They'll be captured!

Wicket chatters in Ewok language, and then takes off full steam into the forest.

THREEPIO: Wa-wait! Wait, come back! Artoo, stay with me.

Inside the bunker, Han looks up from setting charges as an Imperial commander enters.

COMMANDER: Freeze! You Rebel scum.

Han and Leia spin, to find dozens of Imperial weapons trained on them and their cohorts. A poised force of Imperial troops surround them. Ever more pour into the room, roughly disarming the Rebel contingent. Han, Leia, and Chewie exchange looks. They're helpless.

EXTERIOR: SPACE—ENDOR, DEATH STAR, REBEL FLEET

The Death Star and its Sanctuary Moon hang distant in space as the Rebel fleet comes out of hyperspace with an awesome roar.

The Millennium Falcon *and several Rebel fighters are at the front as the space armada bears down on its target.*

INTERIOR: COCKPIT—MILLENNIUM FALCON

Lando flips switches, checks his screen, and speaks into the radio.

LANDO: All wings report in.

WEDGE: Red Leader standing by.

GRAY LEADER: Gray Leader standing by.

GREEN LEADER: Green Leader standing by.

WEDGE: Lock S-foils in attack positions.

INTERIOR: REBEL STAR CRUISER

From the bridge of the Rebel Headquarters Frigate, Admiral Ackbar watches the fighters massing outside his viewscreen.

ACKBAR: May the Force be with us.

INTERIOR: MILLENNIUM FALCON—COCKPIT

Lando looks worriedly at his alien copilot, Nien Nunb, who points to the control panel and talks to Lando.

LANDO: We've got to be able to get some kind of a reading on that shield, up or down. Well, how could they be jamming us if they don't know if we're coming.

Lando shoots a concerned look out at the approaching Death Star as the implications of what he's just said sink in. He hits a switch on his comlink.

LANDO: Break off the attack! The shield is still up.

RED LEADER: *(voice-over)* I get no reading. Are you sure?

LANDO: Pull up! All craft pull up!

The Falcon *turns hard to the left. Out the window the stars and the Death Star move off right.*

EXTERIOR: SPACE—DEATH STAR SHIELD

The Falcon *and the fighters of Red Squad veer off desperately to avoid the unseen wall.*

INTERIOR: REBEL STAR CRUISER—BRIDGE

Alarms are screaming and lights flashing as the huge ship changes course abruptly. Other ships in the fleet shoot by outside as the armada tries to halt its forward momentum.

ACKBAR: Take evasive action! Green Group, stick close to holding sector MV-7.

A Mon Calamari controller turns away from his screen and calls out to Ackbar, quite excited. The admiral rushes over to the controller.

CONTROLLER: Admiral, we have enemy ships in sector 47.

On the screen can be seen the moon, Death Star, and the massive Imperial fleet. Ackbar moves to the comlink.

ACKBAR: It's a trap!

LANDO: *(over comlink)* Fighters coming in.

There is much excitement on the bridge as the attack begins.
 The Millennium Falcon *and several squads of Rebel fighters head into an armada of TIE fighters. The sky explodes as a fierce dogfight ensues in and around the giant Rebel cruisers.*

REBEL PILOT: There's too many of them!

LANDO: Accelerate to attack speed! Draw their fire away from the cruisers.

WEDGE: Copy, Gold Leader.

The battle continues around the giant cruisers.

INTERIOR: DEATH STAR—EMPEROR'S THRONE ROOM

Through the round window behind the Emperor's throne can be seen the distant flashes of the space battle in progress.

EMPEROR: Come, boy. See for yourself.

The Emperor is sitting on his throne, with Vader standing at his side. Luke moves to look through a small section of the window.

EMPEROR: From here you will witness the final destruction of the Alliance, and the end of your insignificant Rebellion.

Luke is in torment. He glances at his lightsaber sitting on the armrest of the throne. The Emperor watches him and smiles, touches the lightsaber.

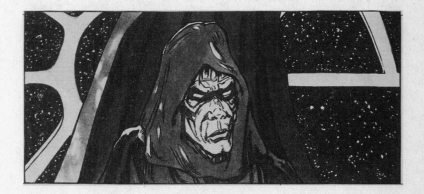

EMPEROR: You want this, don't you? The hate is swelling in you now. Take your Jedi weapon. Use it. I am unarmed. Strike me down with it. Give in to your anger. With each passing moment, you make yourself more my servant.

Vader watches Luke in his agony.

LUKE: No!

EMPEROR: It is unavoidable. It is your destiny. You, like your father, are now mine!

EXTERIOR: FOREST—GENERATOR BUNKER

Han, Leia, Chewie, and the rest of the strike team are led out of the bunker by their captors. The surrounding area, deserted before, is now crowded with two-legged Imperial walkers and hundreds of Imperial troops. The situation looks hopeless.

STORMTROOPER: All right, move it! I said move it! Go on!

From the undergrowth beyond the clearing comes a wild series of beeps and whistles. And—

THREEPIO: Hello! I say, over there! Were you looking for me?

BUNKER COMMANDER: Bring those two down here!

STORMTROOPER: Let's go!

Artoo and Threepio are standing near one of the big trees. As six Imperial stormtroopers rush over to take them captive, the two droids duck out of sight behind the tree.

THREEPIO: Well, they're on their way. Artoo, are you sure this was a good idea?

STORMTROOPER: Freeze! Don't move!

THREEPIO: We surrender.

The stormtroopers come around the tree and find the two droids waiting quietly to be taken. As the Imperial troops move to do that, however, a band of Ewoks drops down from above and overpowers them.

THREEPIO: Ohhh! Stand back, Artoo.

In a nearby tree, an Ewok raises a horn to his lips and sounds the Ewok attack call. All hell breaks loose as hundreds of Ewoks throw their fuzzy bodies into the fray against the assembled stormtroopers and their awesome two-legged walkers.

Biker scouts dart about blasting Ewoks, only to be crushed by a volley of rocks tossed by Ewoks from the trees above.

In the confusion of the battle, Han and Leia break away and dive for the cover of the bunker door as explosions erupt around them. Han goes to the bunker door control panel.

LEIA: The code's changed. We need Artoo!

HAN: Here's the terminal.

LEIA: *(into comlink)* Artoo, where are you? We need you at the bunker right away.

Artoo and Threepio are hiding behind a log as the battle rages around them. Suddenly the stubby little astrodroid lets out a series of whistles and shoots off across the battlefield. Threepio, panicked, runs after him.

THREEPIO: Going? What do you mean, you're going? But— but going where, Artoo? No, wait! Artoo! Oh, this is no time for heroics. Come back!

Biker scouts race around and over the two droids, blasting away at the little Ewoks as the furries scurry for cover.

A group of Ewoks have moved a primitive catapult into position. They fire off a large boulder that hits one of the walkers. The walker turns and heads for the catapult, blasting

away with both guns. The Ewoks abandon their weapons and flee in all directions. Just as the walker moves in to stomp the catapult, Ewoks drop vines restraining two huge logs that swing down and smash the walker's head flat.

A line of Ewoks hang desperately to a vine that is hooked to a walker's foot. As the walker moves along, the fuzzy creatures are dragged behind.

Two speeder bikes chase Ewoks through the underbrush. As the scouts round a tree, they are knocked off their bikes by a vine tied between two trees.

EXTERIOR: OUTER SPACE

The Falcon *and other Rebel fighters are engaged in a ferocious combat with Imperial TIE fighters, the battle raging around the cruisers of the Rebel armada.*

INTERIOR: MILLENNIUM FALCON—COCKPIT

Lando is in radio communication with the pilots of the other Rebel squads.

LANDO: Watch yourself, Wedge! Three from above!

WEDGE: Red Three, Red Two, pull in!

RED TWO: Got it!

RED THREE: Three of them coming in, twenty degrees!

WEDGE: Cut to the left! I'll take the leader! They're heading for the medical frigate.

Lando steers the Falcon *through a complete flip, as his crew fires at the TIEs from the belly guns.*

NAVIGATOR: Pressure's steady.

The copilot Nien Nunb chatters an observation.

LANDO: Only the fighters are attacking . . . I wonder what those Star Destroyers are waiting for.

EXTERIOR: SPACE—IMPERIAL FLEET

The giant Imperial Star Destroyer waits silently some distance from the battle. The Emperor's huge Super Star Destroyer rests in the middle of the fleet.

INTERIOR: SUPER STAR DESTROYER

Admiral Piett and two fleet commanders watch the battle at the huge window of the Super Star Destroyer bridge.

COMMANDER: We're in attack position now, sir.

PIETT: Hold here.

COMMANDER: We're not going to attack?

PIETT: I have my orders from the Emperor himself. He has something special planned for them. We only need to keep them from escaping.

INTERIOR: EMPEROR'S TOWER—THRONE ROOM

The Emperor, Vader, and a horrified Luke watch the aerial battle fireworks out the window and on the viewscreens. Another Rebel ship explodes against the protective shield.

EMPEROR: As you can see, my young apprentice, your friends have failed. Now witness the firepower of this fully armed and operational battle station. *(into comlink)* Fire at will, Commander.

Luke, in shock, looks out across the surface of the Death Star to the Rebel fleet beyond.

INTERIOR: DEATH STAR—CONTROL ROOM

Controllers pull back on several switches. Commander Jerjerrod stands over them.

JERJERROD: Fire!

INTERIOR: DEATH STAR—BLAST CHAMBER

A button is pressed, which switches on a panel of lights.
 A hooded Imperial soldier reaches overhead and pulls a lever. A huge beam of light emanates from a long shaft. Two stormtroopers stand to one side at a control panel.

EXTERIOR: DEATH STAR

The giant laser dish on the completed half of the Death Star begins to glow. Then a powerful beam shoots out toward the aerial battle.

EXTERIOR: SPACE—AIR BATTLE

The air is thick with giant ships. In among them, Rebel X-wings dogfight with Imperial TIE fighters. Now an enormous Rebel cruiser is hit by the Death Star beam and blown to dust.
 The Millennium Falcon *roars over camera, followed closely by several TIE fighters.*

INTERIOR: MILLENNIUM FALCON—COCKPIT

The ship is buffeted by the tremendous explosion of the Rebel cruiser. Lando and his copilot are stunned by the sight of the Death Star firepower.

LANDO: That blast came from the Death Star! That thing's operational! *(into comlink)* Home One, this is Gold Leader.

INTERIOR: REBEL STAR CRUISER—BRIDGE

Ackbar stands amid the confusion on the wide bridge and speaks into the comlink.

ACKBAR: We saw it. All craft prepare to retreat.

LANDO: You won't get another chance at this, Admiral.

ACKBAR: We have no choice, General Calrissian. Our cruisers can't repel firepower of that magnitude.

LANDO: Han will have that shield down. We've got to give him more time.

EXTERIOR: FOREST—GENERATOR BUNKER

Artoo and Threepio make it to the door, as Han and Leia provide cover fire.

THREEPIO: We're coming!

HAN: Come on! Come on!

THREEPIO: Oh, Artoo, hurry!

The little droid moves to the terminal and plugs in his computer arm. A large explosion hits near Artoo, knocking him head over heels, finally landing on his feet. The stubby astrodroid's head is spinning and smoldering. Suddenly there is a loud sprooing and Han and Leia turn around to see Artoo with all his compartment doors open, and all of his appendages sticking out; water and smoke spurt out of the nozzles in his body. Han rushes to the terminal as Threepio rushes to his wounded companion.

THREEPIO: My goodness! Artoo, why did you have to be so brave?

HAN: Well, I suppose I could hotwire this thing.

LEIA: I'll cover you.

Ewoks in handmade, primitive hang gliders drop rocks onto the stormtroopers, dive-bombing their deadly adversaries. One is hit in the wing with laser fire and crashes. A walker lumbers forward, shooting laser blasts at frantic Ewoks running in all directions. Two Ewoks are struck down by laser blasts. One tries to awaken his friend, then realizes that he is dead.

EXTERIOR: SPACE—DEATH STAR

The Rebel fleet continues to be picked off, from one side by the Death Star's deadly beam, from the other by the rampaging Imperial Star Destroyers.

INTERIOR: MILLENNIUM FALCON—COCKPIT

Lando steers the Falcon *wildly through an obstacle course of floating giants. He's been yelling into the comlink.*

LANDO: *(desperately)* Yes! I said *closer*! Move as close as you can and engage those Star Destroyers at point-blank range.

ACKBAR: At that close range, we won't last long against those Star Destroyers.

LANDO: We'll last longer than we will against that Death Star . . . and we might just take a few of them with us.

The Rebel cruisers move very close to the Imperial Star Destroyers and begin to blast away at point-blank range. Tiny fighters race across the giant surfaces, against a backdrop of laser fire.

The control tower of a Star Destroyer is under attack.

REBEL PILOT: She's gonna blow!

Y-WING PILOT: I'm hit!

The damaged Y-wing plummets toward the Star Destroyer, and crashes into the control tower, exploding.

INTERIOR: EMPEROR'S TOWER—THRONE ROOM

Out of the window and on the viewscreens, the Rebel fleet is being decimated in blinding explosions of light and debris. But in here there is no sound of battle. The Emperor turns to Luke.

EMPEROR: Your fleet has lost. And your friends on the Endor moon will not survive. There is no escape, my young apprentice. The Alliance will die . . . as will your friends.

Luke's eyes are full of rage. Vader watches him.

EMPEROR: Good. I can feel your anger. I am defenseless. Take your weapon! Strike me down with all your hatred, and your journey toward the dark side will be complete.

Luke can resist no longer. The lightsaber flies into his hand. He ignites it in an instant and swings at the Emperor. Vader's lightsaber flashes into view, blocking Luke's blow before it can reach the Emperor. The two blades spark at contact. Luke turns to fight his father.

EXTERIOR: FOREST

The battle rages on. Stormtroopers fire on Ewoks with sophisticated weapons while their furry little adversaries sneak up behind the Imperial troopers and bash them over the head with large clubs.

A walker marches through the undergrowth blasting Ewoks as it goes. An Ewok warrior gives the signal, and a pile of logs is cut loose. The logs tumble under the walker's feet, causing it to slip and slide until it finally topples over with a great crash.

A scout bike races past and is lassoed with a heavy vine. The other end of the vine is tied to a tree, and the bike swings

around in ever-tightening circles until it runs out of rope and crashes into the trees with a huge explosion.

Chewie swings on a vine to the roof of one of the walkers. Two Ewoks cling to him. They land with a thud on the top of the lurching machine, then hang on for dear life. One of the Ewoks peeks through the window.

WALKER PILOT #1: Look!

PILOT #2: Get him off of there!

The walker pilot opens the hatch to see what's going on. He is yanked out and tossed overboard before he can scream. The two Ewoks jump into the cockpit and knock the second pilot unconscious. The Ewoks are thrown violently as the mighty machine careens out of control. Outside, Chewie is almost knocked overboard; he sticks his head into the hatch with a series of angry barks. The Ewoks are too busy and frightened to listen to the Wookiee's complaint. Chewie slips inside the walker.

Chewbacca's walker moves through the forest, firing laser blasts at unsuspecting stormtroopers, and destroying other Imperial walkers. The Ewoks shout and cheer as the giant machine helps turn the tide of the battle in their favor.

EXTERIOR: FOREST—GENERATOR BUNKER

Han works furiously at the control panel; wires spark as he attempts to hotwire the door. He motions to Leia, who is blasting away at some stormtroopers.

HAN: I think I got it. I got it!

The three wires spark as the connection is made. With a loud whoosh, a second blast door crashes down in front of the first.

Han frowns and turns back to the wires again. Leia exchanges shots with stormtroopers in the bushes, then suddenly cries out in pain, her shoulder hit by a laser blast.

THREEPIO: Oh, Princess Leia, are you all right?

HAN: Let's see.

LEIA: It's not bad.

STORMTROOPER: *(offscreen)* Freeze!

They freeze.

THREEPIO: Oh, dear.

STORMTROOPER: Don't move!

Leia holds her laser gun ready, behind Han, out of view of the two stormtroopers moving toward them. Han and Leia's eyes lock; the moment seems suspended in time.

HAN: I love you.

Another shared look between them, as she smiles up at Han.

LEIA: I know.

STORMTROOPER: Hands up! Stand up!

Han stands up slowly and turns, revealing the gun in Leia's hand. She disposes of the stormtroopers in a flash. As Han turns

back toward Leia, he looks up to see a giant walker approach and stand before him, its deadly weapons aimed right at him.

HAN: *(to Leia)* Stay back.

The hatch on top of the walker opens and Chewie sticks his head out and barks triumphantly.

HAN: Chewie! Get down here! She's wounded! No, wait . . . I got an idea.

INTERIOR: EMPEROR'S TOWER—THRONE ROOM

Luke and Vader are engaged in a man-to-man duel of lightsabers even more vicious than the battle on Bespin. But the young Jedi has grown stronger in the interim, and now the advantage shifts to him. Vader is forced back, losing his balance, and is knocked down the stairs. Luke stands at the top of the stairs, ready to attack.

EMPEROR: *(laughing)* Good. Use your aggressive feelings, boy! Let the hate flow through you.

Luke looks momentarily toward the Emperor, then back to Vader, and realizes he is using the dark side. He steps back, turns off his lightsaber, and relaxes, driving the hate from his being.

VADER: Obi-Wan has taught you well.

LUKE: I will not fight you, Father.

Vader walks back up the stairs to Luke.

VADER: You are unwise to lower your defenses.

Vader attacks, forcing Luke on the defensive. The young Jedi leaps in an amazing reverse flip up to the safety of the catwalk overhead. Vader stands below him.

LUKE: Your thoughts betray you, Father. I feel the good in you . . . the conflict.

VADER: There is no conflict.

LUKE: You couldn't bring yourself to kill me before, and I don't believe you'll destroy me now.

VADER: You underestimate the power of the dark side. If you will not fight, then you will meet your destiny.

Vader throws the laser sword and it cuts through the supports holding the catwalk, then returns to Vader's hand. Luke tumbles to the ground in a shower of sparks and rolls out of sight under the Emperor's platform. Vader moves to find him.

EMPEROR: *(laughs)* Good. Good.

EXTERIOR: SPACE—AIR BATTLE

The two armadas, like their sea-bound ancestors, blast away at each other in individual point-blank confrontations. A Star Destroyer explodes. The Rebel victor limps away, its back half alive with a series of minor explosions. The Rebel cruiser manages to move in next to a second Star Destroyer before it explodes completely, taking the Imperial Star Destroyer with it. The Falcon *and several fighters attack one of the larger Imperial ships.*

LANDO: Watch out. Squad at .06.

REBEL PILOT: I'm on it, Gold Leader.

WEDGE: Good shot, Red Two.

LANDO: Now . . . come on, Han, old buddy. Don't let me down.

INTERIOR: BUNKER CONTROL ROOM

*Controllers watch the main viewscreen on which a vague figure
of an Imperial walker pilot can be seen. There is a great deal of
static and interference.*

HAN/PILOT: *(voice-over)* It's over, Commander. The Rebels
have been routed. They're fleeing into the woods. We need
reinforcements to continue the pursuit.

The controllers cheer.

CONTROL ROOM COMMANDER: Send three squads to help.
Open the back door.

SECOND COMMANDER: Yes, sir.

EXTERIOR: FOREST—GENERATOR BUNKER

*As the door to the bunker opens and the Imperial troops rush
out, they're surprised to find themselves surrounded by Rebels,
their weapons pointed at them. Ewoks holding bows and
arrows appear on the roof of the bunker. The Imperial troops
throw down their guns as Han and Chewie rush inside the
bunker with explosive charges.*

INTERIOR: BUNKER

*Han, Chewie, and several troops rush into the control room,
plant explosive charges on the control panels, and rush out.*

HAN: Throw me another charge.

INTERIOR: EMPEROR'S TOWER—THRONE ROOM

*Vader stalks the low-ceilinged area on the level below the
throne, searching for Luke in the semidarkness, his lightsaber
held ready.*

VADER: You cannot hide forever, Luke.

LUKE: I will not fight you.

VADER: Give yourself to the dark side. It is the only way you can save your friends. Yes, your thoughts betray you. Your feelings for them are strong. Especially for . . .

Vader stops and senses something. Luke shuts his eyes tightly, in anguish.

VADER: Sister! So . . . you have a twin sister. Your feelings have now betrayed her, too. Obi-Wan was wise to hide her from me. Now his failure is complete. If you will not turn to the dark side, then perhaps she will.

LUKE: Never-r-r!

Luke ignites his lightsaber and screams in anger, rushing at his father with a frenzy we have not seen before. Sparks fly as Luke and Vader fight in the cramped area. Luke's hatred forces Vader to retreat out of the low area and across a bridge overlooking a vast elevator shaft. Each stroke of Luke's sword drives his father further toward defeat.

The Dark Lord is knocked to his knees, and as he raises his sword to block another onslaught, Luke slashes Vader's right hand off at the wrist, causing metal and electronic parts to fly from the mechanical stump. Vader's sword clatters uselessly

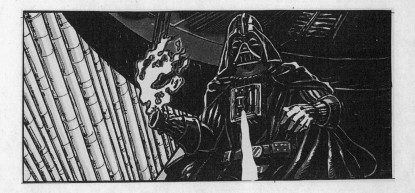

away, over the edge of the platform and into the bottomless shaft below. Luke moves over Vader and holds the blade of his sword to the Dark Lord's throat. The Emperor watches with uncontrollable, pleased agitation.

EMPEROR: Good! Your hate has made you powerful. Now, fulfill your destiny and take your father's place at my side!

Luke looks at his father's mechanical hand, then to his own mechanical, black-gloved hand, and realizes how much he is becoming like his father. He makes the decision for which he has spent a lifetime in preparation. Luke steps back and hurls his lightsaber away.

LUKE: Never! I'll never turn to the dark side. You've failed, Your Highness. I am a Jedi, like my father before me.

The Emperor's glee turns to rage.

EMPEROR: So be it . . . Jedi.

EXTERIOR: FOREST—GENERATOR BUNKER

Han and several fighters run out of the bunker and race across the clearing.

HAN: Move! Move!

A shock wave knocks them flat as the bunker explodes, followed by a spectacular display as the huge shield-generator radar dish explodes along with the bunker.

INTERIOR: REBEL STAR CRUISER—BRIDGE

Ackbar, sitting in his control chair, speaks into the radio.

ACKBAR: The shield is down! Commence attack on the Death Star's main reactor.

LANDO: We're on our way. Red Group, Gold Group, all fighters follow me. *(laughs)* Told you they'd do it!

The *Falcon, followed by several smaller Rebel fighters, heads toward the unfinished superstructure of the Death Star.*

INTERIOR: EMPEROR'S TOWER—THRONE ROOM

Luke stands still, as the Emperor reaches the bottom of the stairs. The Emperor's laughter has turned to anger. He raises his arms toward Luke.

EMPEROR: If you will not be turned, you will be destroyed.

Blinding bolts of energy, evil lightning, shoot from the Emperor's hands at Luke. Even in his surprise, the young Jedi tries to use the Force to deflect them. At first he is half successful, but after a moment the bolts of energy are coming with such speed and power the young Jedi shrinks before them, his knees buckling. The wounded Vader struggles to his feet, and moves to stand at his master's side.

EMPEROR: Young fool . . . only now, at the end, do you understand.

Luke is almost unconscious beneath the continuing assault of the Emperor's lightning. He clutches a canister to keep from falling into the bottomless shaft as the bolts tear through him.

EMPEROR: Your feeble skills are no match for the power of the dark side. You have paid the price for your lack of vision.

Luke writhes on the floor in unbearable pain, reaching weakly up toward where Vader stands watching.

LUKE: *(groans)* Father, please. Help me.

Again Vader stands, watching Luke. He looks at his master, the Emperor, then back to Luke on the floor.

EMPEROR: Now, young Skywalker . . . you will die.

Although it would not have seemed possible, the outpouring of bolts from the Emperor's fingers actually increases in intensity, the sound screaming through the room. Luke's body writhes in pain.

Vader grabs the Emperor from behind, fighting for control of the robed figure despite the Dark Lord's weakened body and gravely weakened arm. The Emperor struggles in his embrace, his bolt-shooting hands now lifted high, away from Luke. Now the white lightning arcs back to strike at Vader. He stumbles with his load as the sparks rain off his helmet and flow down over his black cape. He holds his evil master high over his head and walks to the edge of the abyss at the central core of the throne room. With one final burst of his once awesome strength, Darth Vader hurls the Emperor's body into the bottomless shaft.

The Emperor's body spins helplessly into the void, arcing as it falls into the abyss. Finally, when the body is far down the shaft, it explodes, creating a rush of air through the room. Vader's cape is whipped by the wind and he staggers, and collapses toward the bottomless hole. Luke crawls to his father's side and

pulls him away from the edge of the abyss to safety. Both the young Jedi and the giant warrior are too weak to move.

EXTERIOR/INTERIOR: SPACE BATTLE—FIGHTER AND DEATH STAR

Rebel fighters follow the Falcon *across the surface of the Death Star to the unfinished portion, where they dive into the superstructure of the giant battle station, followed by many TIE fighters.*

WEDGE: I'm going in.

LANDO: Here goes nothing.

Three X-wings lead the chase through the ever-narrowing shaft, followed by the Falcon *and four other fighters, plus TIE fighters who continually fire at the Rebels. Lights reflect off the pilots' faces as they race through the dark shaft.*

LANDO: Now lock onto the strongest power source. It should be the power generator.

WEDGE: Form up. And stay alert. We could run out of space real fast.

The fighters and the Falcon *race through the tunnel, still pursued by the TIE fighters. One of the X-wings is hit from behind and explodes.*

LANDO: Split up and head back to the surface. See if you can get a few of those TIE fighters to follow you.

PILOT: Copy, Gold Leader.

The Rebel ships peel off pursued by three of the TIEs, while Lando and Wedge continue through the main tunnel. It narrows, and the Falcon *scrapes the side dangerously. Two other TIE fighters continue to blast away at them.*

STAR WARS

LANDO: That was too close.

Nien Nunb agrees. The battle between the Rebel and Imperial fleets rages on. Several cruisers fire at the giant Super Star Destroyer.

INTERIOR: REBEL STAR CRUISER—BRIDGE

ACKBAR: We've got to give those fighters more time. Concentrate all fire on that Super Star Destroyer.

X-wing pilots head across the surface of the huge battleship.

INTERIOR: VADER'S STAR DESTROYER—BRIDGE

Admiral Piett and a commander stand at the window, looking out to the battle. They look concerned.

CONTROLLER: Sir, we've lost our bridge deflector shield.

PIETT: Intensify the forward batteries. I don't want anything to get through.

The commander is looking out of the window where a damaged Rebel fighter is out of control and heading directly toward the bridge.

PIETT: Intensify forward firepower!

COMMANDER: It's too late!

The Rebel pilot screams as his ship hits the Star Destroyer, causing a huge explosion. The giant battleship loses control, crashes into the Death Star, and explodes.

INTERIOR: REBEL STAR CRUISER

There is excitement on the bridge as the battle rages on all sides. They cheer as the giant Star Destroyer blows up.

INTERIOR: DEATH STAR—MAIN DOCKING BAY

Chaos. For the first time, the Death Star is rocked by explosions as the Rebel fleet, no longer backed against a wall, zooms over, unloading a heavy barrage. Imperial troops run in all directions, confused and desperate to escape.

In the midst of this uproar, Luke is trying to carry the enormous dead weight of his father's weakening body toward an Imperial shuttle. Finally, Luke collapses from the strain. The explosions grow louder as Vader draws him closer.

VADER: *(a whisper)* Luke, help me take this mask off.

LUKE: But you'll die.

VADER: Nothing can stop that now. Just for once . . . let me look on you with my own eyes.

Slowly, hesitantly, Luke removes the mask from his father's face. There beneath the scars is an elderly man. His eyes do not focus. But the dying man smiles at the sight before him.

ANAKIN: *(very weak)* Now . . . go, my son. Leave me.

LUKE: No. You're coming with me. I can't leave you here. I've got to save you.

ANAKIN: You already have, Luke. You were right. You were right about me. Tell your sister . . . you were right.

LUKE: Father . . . I won't leave you.

Darth Vader, Anakin Skywalker . . . Luke's father dies.

A huge explosion rocks the docking bay. Slowly, Luke rises and, half carrying, half dragging the body of his father, stumbles toward a shuttle.

EXTERIOR: DEATH STAR

The Millennium Falcon *leads a swerving bomb run through the immense superstructure of the half-built Death Star. The Rebel Star Cruisers outside continually bombard the huge station. And each direct hit is answered by resonating, chain-reaction explosions within the station itself.*

INTERIOR: FALCON COCKPIT AND GUN PORTS

Lando's crew fires away at the pursuing TIE fighters as the dashing Baron of Bespin and his alien copilot home in on the main reactor shaft. It is awesome. A lone X-wing is just in front of the Falcon.

WEDGE: There it is!

LANDO: All right, Wedge. Go for the power regulator on the north tower.

WEDGE: Copy, Gold Leader. I'm already on my way out.

The X-wing heads for the top of the huge reactor and fires several proton torpedoes at the power regulator, causing a series of small explosions.

The Falcon *heads for the main reactor, and when it is dangerously close, Lando fires the missiles, which shoot out of the* Falcon *with a powerful roar, and hit directly at the center of the main reactor.*

He maneuvers the Falcon *out of the winding superstructure just ahead of the continuing chain of explosions.*

INTERIOR: REBEL STAR CRUISER

Ackbar and other Mon Calamari lean on the railing of the bridge, watching the large screen showing the Death Star in the main briefing room.

ACKBAR: Move the fleet away from the Death Star.

EXTERIOR: DEATH STAR

An Imperial shuttle, with Luke alone in the cockpit, rockets out of the main docking bay as that entire section of the Death Star is blown away.

Finally, just as it looks like the Falcon *will not make it, Lando expertly pilots the craft out of the exploding superstructure and whizzes toward the Sanctuary Moon, only a moment before the Death Star supernovas into oblivion.*

INTERIOR: MILLENNIUM FALCON—COCKPIT

Lando and Nien Nunb laugh and cheer in relief.

EXTERIOR: ENDOR FOREST

Han and Leia, Chewie, the droids, the Rebel troops, and the Ewoks all look to the sky as the Death Star reveals itself in a final flash of self-destruction. They all cheer.

THREEPIO: They did it!

Han looks down from the sky to Leia, a look of concern on his face. Leia continues to look at the sky as though listening for a silent voice.

HAN: I'm sure Luke wasn't on that thing when it blew.

LEIA: He wasn't. I can feel it.

HAN: You love him, don't you?

Leia smiles, puzzled.

LEIA: Yes.

HAN: All right. I understand. Fine. When he comes back, I won't get in the way.

She realizes his misunderstanding.

LEIA: Oh. No, it's not like that at all. He's my brother.

Han is stunned by this news. She smiles, and they embrace.

EXTERIOR: ENDOR FOREST—NIGHT

Luke sets a torch to the logs stacked under a funeral pyre where his father's body lies, again dressed in black mask and helmet. He stands, watching sadly, as the flames leap higher to consume Darth Vader—Anakin Skywalker.
 In the sky above, fireworks explode and Rebel fighters zoom above the forest.

EXTERIOR: EWOK VILLAGE SQUARE—NIGHT

A huge bonfire is the centerpiece of a wild celebration. Rebels and Ewoks rejoice in the warm glow of firelight, drums beating, singing, dancing, and laughing in the communal language of victory and liberation.
 Lando runs in and is enthusiastically hugged by Han and Chewie. Then, finally, Luke arrives and the friends rush to greet and embrace him. They stand close, this hardy group, taking comfort in each other's touch, together to the end.

Rebels and Ewoks join together in dancing and celebration. The original group of adventurers watches from the sidelines. Only Luke seems distracted, alone in their midst, his thoughts elsewhere.

He looks off to the side and sees three shimmering, smiling figures at the edge of the shadows: Ben Kenobi, Yoda, and Anakin Skywalker.

FADE OUT.

END CREDITS OVER STAR FIELD.

THE END.